IMAGES
of America

PEN MAR

D1478505

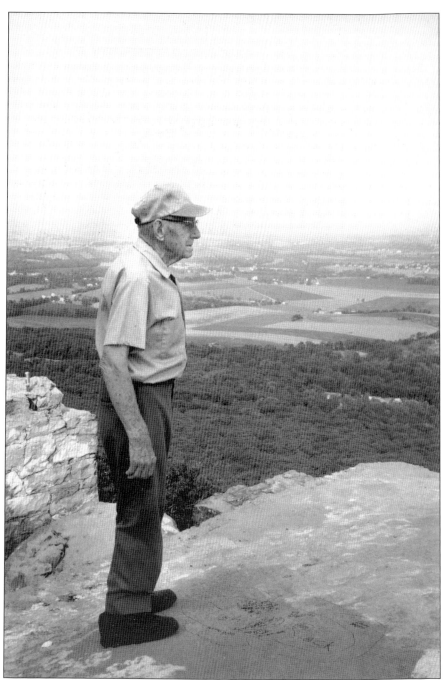

Richard Happel Sr., born July 4, 1909, stands atop High Rock overlooking the floor of th Cumberland Valley below. Happel's grandfather George Washington Kettoman suggested t officials of the Western Maryland Railway that High Rock, at an elevation of 2,000 feet abov sea level, would be an excellent site for an observatory near Pen Mar Park, which opened i 1877. The three-tiered wooden observatory built a year later enabled 500 visitors to view "tw thousand square miles of fairy land," according to an 1879 brochure. One of the piers that onc supported the observatory can be seen at the left. (Courtesy *Maryland Cracker Barrel*.)

IMAGES
of America

PEN MAR

Franklin P. Woodring and Suanne K. Woodring

ARCADIA

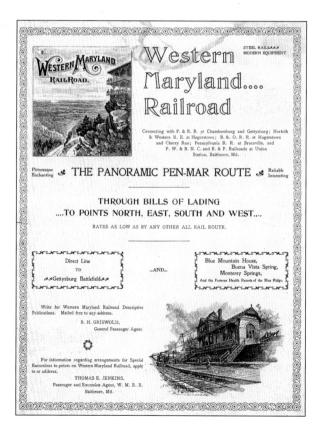

An ad appearing in an 1897 publication promoting the 100th anniversary of nearby Waynesboro, Pennsylvania, touts the benefits of the Western Maryland Railway, which established the Blue Ridge Mountains along the Mason-Dixon Line as one of the premier resort areas on the East Coast. In 1898, the Western Maryland hauled 1,200,956 passengers, 558,248 of whom were excursionists. (Courtesy Mrs. Zel Smith.)

CONTENTS

ACKNOWLEDGMENTS

Without the cooperation of a vast array of individuals and groups, this glimpse of Pen Ma
would not have been possible. The driving motivation behind this project undoubtedly was th
intense passion for Pen Mar by those who were associated with the park and still posse.
treasured memories. Last summer we were fortunate enough to attend the annual reunion c
former Pen Mar Park employees, and as they shared their stories, it was obvious time had nc
diminished their love of the "glory years" of the park. We thank those who were at the reunio
for inspiring us: Betty Frazer Brown, Virginia Bruneske, Lindy Bumbaugh, June Miller Clin
Randolph Debrick, Paul Frazer, Jim Keenan, Frank Rosenberger, Dolores Getty Sattler, Alle
Smetzer, and Charles Trite. We have visited with Virginia Bruneske and Lindy Bumbaugh c
numerous occasions as they graciously shared their archives of local history. We thank Dolore
Sattler for providing pictures and material written by her grandfather John J. Gibbons Sr., wh
managed two of the largest hotels in the Blue Ridge.

Richard Happel Sr. served as one of our historians for the Blue Ridge area. Having sper
much time with him, we understandably refer to him as "The Grand Gentleman of the Blu
Ridge." We also thank Mrs. Zel Smith for sharing from her collection of local history.

In 1977, Judy Schlotterbeck published *The Pen Mar Story*, undoubtedly the definitive wor
on the history of the park. We appreciate Judy's willingness to share her vast research.

We also acknowledge Virginia Ludwig and Janet Dayhoff, who shared their collections c
Pen Mar memorabilia. Bob Shives of the Western Maryland Railway Historical Socie
(WMRHS) gladly opened the group's archives to us, as did David Cline, who is also associate
with the WMRHS. David, who has an intense love of history, served as one of our authoriti
on the Western Maryland's connection with Pen Mar. David's parents, Gene and Mary Le
Cline, also contributed.

Earl and Beckie Blair, along with their son John E.N. Blair, were instrumental in providir
photos and information. We also thank Jim Powers, who is the driving force behind th
concerts at Pen Mar Park today.

Our gratitude goes to James L. Sterling, director of the Washington County Building
Grounds, and Parks Department, who made available to us the photo on the cover, which ha
been contributed to the county by the Fleigh family.

John Frye of the Western Maryland Room of the Washington County Free Library, Charl
Slick of the Smithsburg Historical Society, Mindy Marsden of the Washington Coun
Historical Society, Dr. Kathryn Oller of the Waynesboro Historical Society, and Ann Hull c
the Kittochtinny Historical Society in Chambersburg all contributed to the project. Lola Ar
McBee, Ann Garrot, Frank Tosh, Mr. and Mrs. William E. Reed Sr., Robert A. Fahnestock Jr
Dottie Crawford from the Washington Square United Methodist Church in Hagerstown, ar
Nancy Gehr from the Hagerstown Church of the Brethren all contributed pictures or inciden
relating to the park.

We recognize the numerous individuals who have been interviewed over the years for th
Maryland Cracker Barrel magazine.

This book is dedicated to all of those whose passion for Pen Mar Park made *Images c
America: Pen Mar* a reality.

INTRODUCTION

"Goin' to Pen Mar" was a popular refrain echoed along the East Coast for 66 years by untold thousands. Attracted by a view that spanned 30 miles from the Blue Ridge Mountains across the Cumberland Valley to the Alleghenies, visitors flocked to the Pen Mar area.

When the Western Maryland Railway reached Hagerstown, the county seat of Washington County, Maryland, in 1872, the die was cast. All that was needed was someone who realized the potential of the region. That individual was Col. John Mifflin Hood, who became president of the Western Maryland Railway in 1874. In order to promote excursion trains to the Blue Ridge Mountains, Colonel Hood conceived the idea for a summer resort, complete with an amusement park. Colonel Hood's initial choice was the future site of Camp Ritchie, which became the training site for the Maryland National Guard in 1926. Upon the recommendation of Peter Rouzer, founder of nearby Rouzerville, Hood settled on a site along the Maryland-Pennsylvania border that offered a view of 2,000 square miles between the two mountain ranges from an elevation of 1,400 feet.

Colonel Hood's dream was realized when Pen Mar Park opened on August 31, 1877. Initially, two of the most popular attractions at the new park were the dance pavilion and a dining room with a seating capacity of 450 and 50¢ chicken dinners. A year later, the railroad constructed a three-tiered wooden observation tower accommodating 500 visitors two-and-a-half miles from the park at an elevation of 2,000 feet. From here on a clear day, one could see the town clock in Chambersburg, Pennsylvania, at a distance of 24 miles—with binoculars, of course. In the early 1880s, the road was extended another two miles to Mt. Misery, later renamed Mt. Quirauk, an Indian name meaning "blue mountain." Here, at an elevation of 2,400 feet, a 70-foot wooden tower was built.

In 1884, a round-trip carriage ride from Pen Mar Park to High Rock was 15¢. A timetable published by the Western Maryland noted, "Passengers are cautioned against using any conveyances excepting such as are recognized by the Railroad Co., whose drivers are indicated by badges." A round-trip fare from Baltimore on the Western Maryland Railway cost $1 for the 81-mile, 3-hour ride through the Maryland countryside. The Blue Mountain Express, with its plush gas-lit cars, operated out of Baltimore's Hillen Station and was considered the finest train out of the city in its time. So popular was the Pen-Mar Express on Sundays and holidays during the summer that the Western Maryland sometimes had to borrow coaches from the Pennsylvania Railroad to accommodate the throngs going to Pen Mar.

In 1904, William Fleigh, a Western Maryland engineer, introduced what became one of the most popular attractions at the park, a miniature railroad line. An engine, tender, and three open cars were purchased for $1,500. The locomotive was only three feet high, but it burned hard coal and sported a brass bell, whistle, and headlight. Initially, the track was straight, but in 1905, Fleigh designed a figure-eight track that offered a five-minute ride. As many as 2,000 people would ride the miniature train daily. Later, Fleigh added a second train. In the 39 years the trains operated, over 750,000 passengers enjoyed the "Little Wabash" and its companion locomotive.

With the allure of amusement rides—including a carousel with brass rings—to complement the panoramic view, the popularity of the fashionable resort area blossomed. Typically,

"Everybody's Day" attracted the largest crowds of the summer. The record attendance for Pen Mar Park on a single day approached 20,000. For many, a trip to Pen Mark Park was the highlight of the summer, and crowds of 4,000 to 5,000 visitors on weekdays were not unusual. For many churches, businesses, and organizations, "goin' to Pen Mar" was a cherished moment. A Lutheran picnic in the early 1920s brought a crowd estimated at 15,000.

To oblige those retreating to the mountains to escape the summer heat, several hotels and nearly 100 boarding houses dotted the area. One of the early hotels, the Blue Mountain House, was constructed in 1883 in just 76 working days. The first-class resort hotel could accommodate 400 guests, who paid $14 to $21 a week.

John J. Gibbons Sr., who became manager of the hotel in 1896, reflected on a lost era when he said in 1969, "I suppose it is hard for people today to realize the charm of those hazy, blue mountains with their breath-taking scenery and fresh, sparkling air. Guests at the hotel seemed to find a long carriage ride through the mountain region or just taking walks along scenic paths enjoyable. But most of all, guests liked to sit in those big rocking chairs on the long, shady veranda of the hotel, greeting old friends and passing hours in conversation. Good food, pure water from mineral springs, and the pleasure of just sitting still for a while seemed to satisfy us so much in those days."

One

GOIN' TO PEN MAR

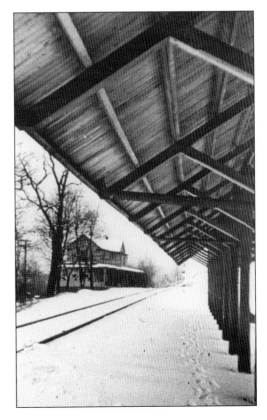

The solitude of winter surrounds the Western Maryland Railway station at Pen Mar. The station was situated south of the Mason-Dixon Line, putting it in Maryland, while the Pen Mar Post Office (background) sat on the other side of the track in Pennsylvania. With the coming of spring, the fashionable resort area would slowly awaken, as visitors soon occupied rockers on the porches of more than 100 hotels and boarding houses in the area. (Courtesy Virginia Bruneske, Wissel Collection.)

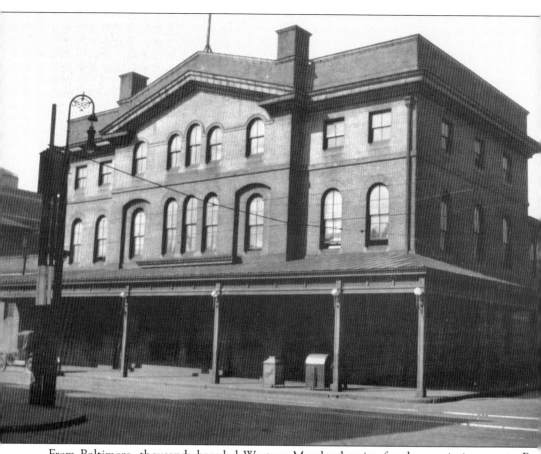

From Baltimore, thousands boarded Western Maryland trains for the scenic journey to Pen Mar, known as "The Alps of America." As a youngster, Jim Keenan spent the summers at his family's home on High Rock Road above Pen Mar Park. He remembers taking the train from Hillen Station "because we didn't have a car. We would get the No. 8 streetcar, which was only a block from where we lived. We'd ride the streetcar down to Hillen Station—walk into the station and take the train up to Pen Mar. It was a fascinating building. It had an all-brick concourse with a peaked roof. They had these wrought iron gates that we would go through to get on the train." Col. John Mifflin Hood, president of the Western Maryland, had his office on the second floor of Hillen Station. A bell in his office alerted Hood each time a train left the station. The bell would ring three times to indicate he had three minutes to get the train. Hillen Station, which opened on February 1, 1876, was the "shining gem of the growing railroad," with up to 42 passenger trains going and coming daily. (Courtesy of WMRHS.)

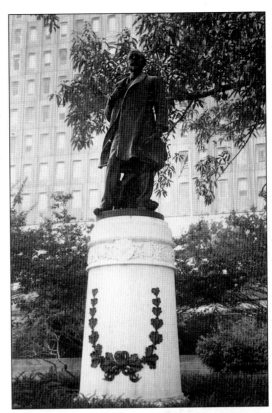

When John Mifflin Hood (right) became president of the Western Maryland Railway (WM) in 1874, the company had 0 miles of track and 12 locomotives "asthmatic from overwork." The track extended from Baltimore to Williamsport, where boatloads of coal from the C&O Canal were loaded on the trains. When Hood resigned in 1902, the WM had nearly 270 miles of additional track, 71 locomotives, a large amount of rolling stock, and gross earnings of $2,119,473.62. Hood was so focused on the railroad that he seldom took vacations. On numerous occasions he spurned buyouts from larger railroads. In the early years, he declined taking his full salary, which never surpassed $10,000 a year. Hood's statue is at Preston Gardens on St. Paul Street near Mercy Hospital in Baltimore. Below, at Hillen Station, No. 202 is ready to head west toward the Blue Ridge. (Courtesy *Maryland Cracker Barrel* and the WMRHS.)

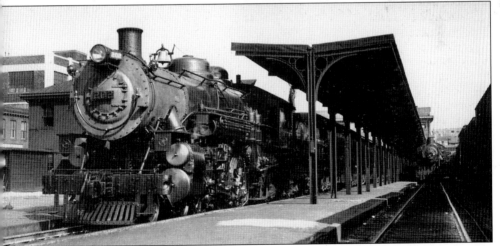

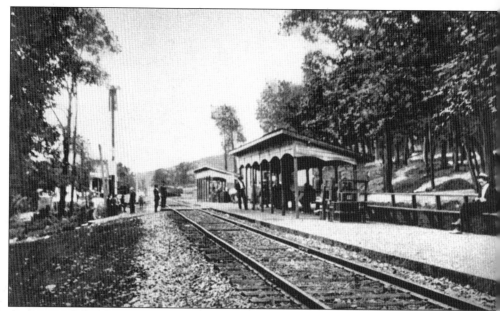

A picture of the original Western Maryland station at Pen Mar is seen above. The station served patrons of Pen Mar Park, which opened in the summer of 1877. In a 1936 feature, the *Baltimore News American* described the anticipation of a trip to Pen Mar Park. "Hillen Station, now shadowed by the new viaduct, was a busy place, teaming with young and old folk carrying baskets and boxes filled with appetizing lunches." (Courtesy Judy Schlotterbeck.)

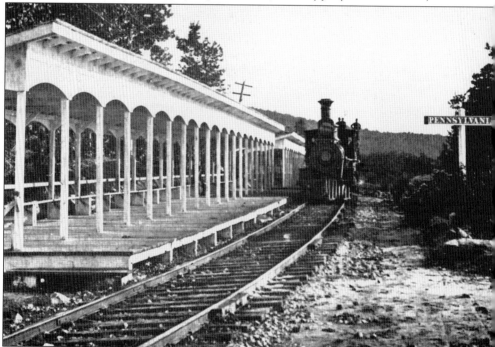

The photo of a train arriving at Pen Mar from the west was taken by photographer Elias Marker Recher around 1878 and is thought to be one of the earliest pictures of Pen Mar Station. (Courtesy *Maryland Cracker Barrel.*)

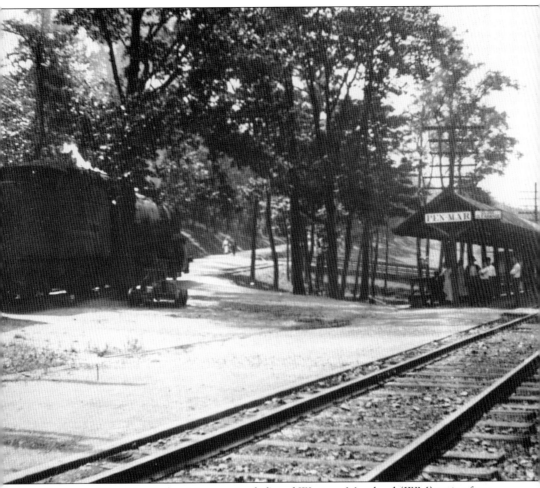

In the early years of Pen Mar Park, visitors arrived aboard Western Maryland (WM) trains from the west as well as the east. At one time, a siding above the Pen Mar Station took passengers directly to the park. The Pen Mar Express out of Baltimore's Hillen Station usually ran four or five sections of ten or more cars each on Sundays and holidays. On these occasions, lines stretched for blocks as passengers waited to purchase tickets. According to an 1880 Western Maryland report, the resort area took on new meaning. "An elevation of 600 feet now being considered beyond the reach of malarial influences, the large exempted areas upon the Western Maryland up to three times this elevation, coupled with unsurpassed scenic attractions have each successive season commanded greater attention, until the names Pen-Mar and High Rock have become household terms with the people of our tide-water city." Harry N. Newberry, brother of WM engineer Robert Garfield Newberry, recounts one of his brother's tasks at Pen Mar. "He would get out the long-spouted oil can and do what all engineers used to do: oil the working parts. Always a group of the curious would gather, and he would explain to all just what the huge locomotive was all about. It became one of the rituals of going to Pen Mar." (Courtesy Lindy Bumbaugh.)

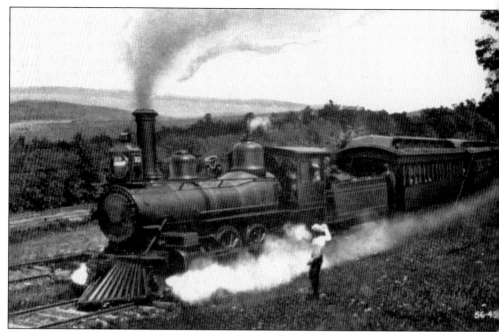

The Pen Mar Express arrives on the siding below Pen Mar Park. Excursion trains out of Baltimore ran almost daily, bringing thousands of visitors. Trains from Hillen Station would leave at 9:15 a.m. and reach the park before noon, with the return trip arriving back in Baltimore around 8 p.m. Harry N. Newberry remembers WM locomotives and tenders "going up the track and stopping to permit the endless line of coaches to open in the platform area" at Hillen Station. Periodically throughout the summer, the WM would run moonlight excursions to the park. (Courtesy *Maryland Cracker Barrel*.)

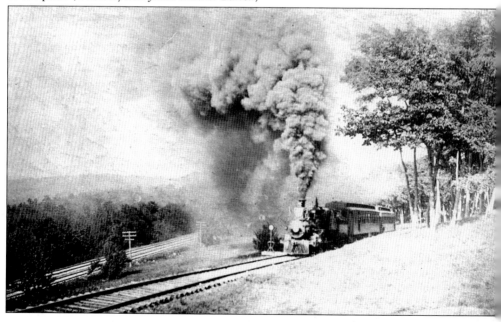

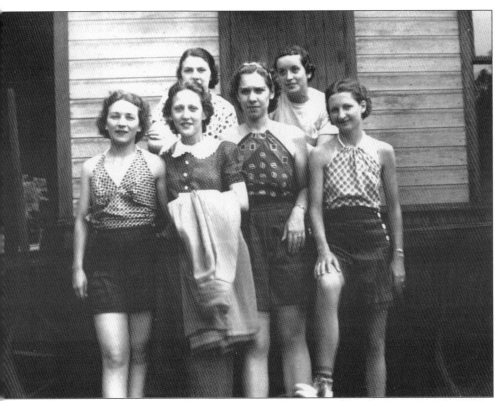

For several summers, a group of young women escaped the city to spend part of the summer at Pen Mar. The ladies above are, from left to right, (front row) Jane Rohrer Norman, Elizabeth Bowman Bittle, Mary Louise Rockwell Mason, and Virginia Rohrer Ludwig; (back row) Doris Ensminger and Gail Mitchell Kerfoot. In the summer, young couples took advantage of a special Western Maryland train called "The Moonlight Special," which departed from Hagerstown at 7:30 p.m. and left the Pen Mar Station at 11:30 p.m. for the return trip to Hagerstown. Live bands at Pen Mar Park's dance pavilion provided a romantic setting for young and old alike. (Courtesy Virginia Ludwig and the WMRHS.)

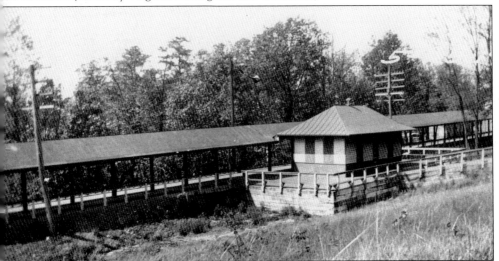

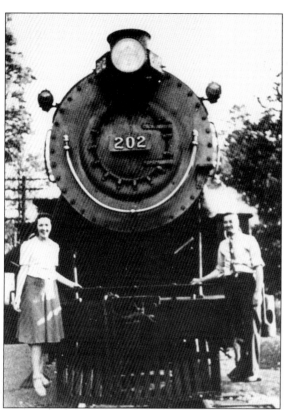

For more than 80 years, Wryrick and Marcella Wissel's family, from the Baltimore area, have spent their summers in the Pen Mar area. Flanking Western Maryland No. 202 at Pen Mar are Miriam and Gerard Wissel. (Courtesy Virginia Bruneske, Wissel Collection.)

A Western Maryland train arrives at the Pen Mar Station from Baltimore. The Pen Mar Station was one of the flag stops along the WM route, according to Lindy Bumbaugh, and in the photo a flag can be seen hanging from the station indicating that there were passengers to board the train. Bumbaugh noted that the flags were green and white. (Courtesy Virginia Bruneske, Wissel Collection.)

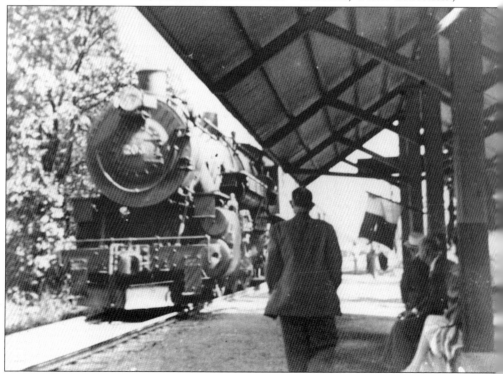

WM engineer William N. Fleigh operates an eastbound train near the bridge leading to Glen Afton Spring west of Pen Mar Park. Trains stopped in Chewsville, Cavetown, Smithsburg, and Edgemont as they started the steady climb up to Pen Mar. Former WM engineer J.R. Leight remembers, "We used to go up the mountain over there going up toward Smithsburg—them old engines would be chugging away, and I had a conductor, and he'd sit up there on the seat behind the fireman. He'd hunch every time the engine puffed. He leaned forward like he was helping it up the mountain." (Courtesy Judy Schlotterbeck.)

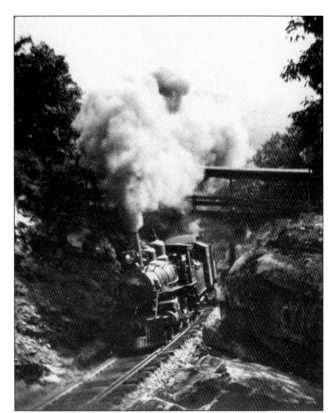

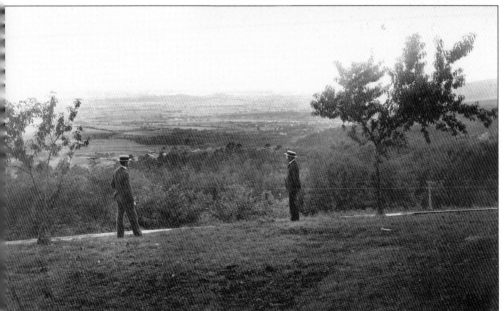

Two gentlemen stand above the Western Maryland tracks at Pen Mar Park. Lindy Bumbaugh recalls passengers "bailing out of trains before they came to a stop" at the Pen Mar Station. Bumbaugh adds that park employees gathered to watch trains arriving, then scampered back to their jobs to accommodate the incoming visitors. (Courtesy Virginia Bruneske.)

As trains departed from Hillen Station to begin the journey to the Blue Ridge Mountains, conductors passed among the passengers distributing free copies of the *Pen Mar Echo*, a Western Maryland publication giving bits of information such as lodging, restaurants, and attractions in the Pen Mar area. In the infancy of Pen Mar Park, the Western Maryland Railway added to the allure of the train as a means of transportation to the resort atop the Blue Ridge. Former WM engineer Harry Hamby reflected on the atmosphere of the railroad, "I liked it! I did! I loved railroading! It seemed like each day was a little different—wasn't the same thing all the time. We were a family railroad! Anybody that worked there will tell you that. We would sort of look after one another—like if I was a young man, and I went on the job as fireman, well, the rest of the crew would look out for you. The Western Maryland Railroad was strictly a family railroad!" (Courtesy Virginia Bruneske.)

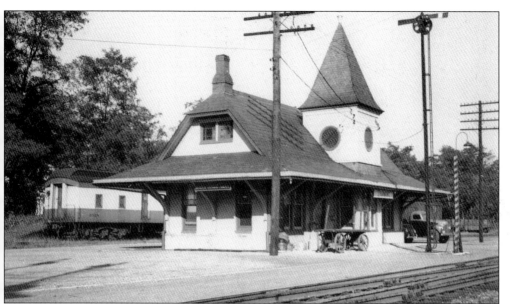

The WM station at Thurmont, Maryland, is pictured prior to 1954. The Hagerstown & Frederick Railway (H&F) brought passengers by trolley from Frederick to Thurmont. The H&F had its own wood-frame passenger and freight station where the WM crossed Main Street in Thurmont. In 1811, the town was known as Mechanicstown, but when the area became a popular resort the name changed to Thurmont, "gateway to the mountains," where passengers from Frederick "goin' to Pen Mar" could board WM trains. (Courtesy WMRHS.)

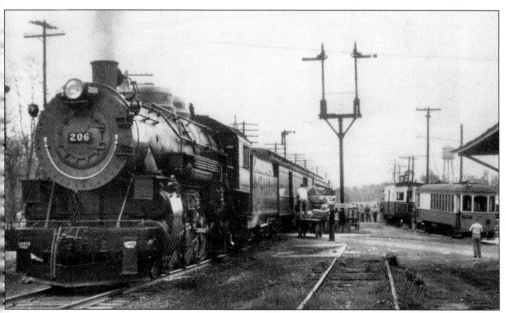

A WM train in Thurmont on May 6, 1951, waits to proceed. On the right are Potomac Edison inter-urbans No. 5 and No. 171 loading mail and express for Frederick. In the early days of the H&F, the trolley made as many as eight round trips from Frederick to Thurmont, where the WM ran four trains daily through the Catoctin Mountain community. (Courtesy WMRHS.)

A brochure promoting the two-hour trip from Baltimore to Pen Mar emphasizes the "magnificent and varied scenery" and proclaims the landscape as "some of the most spectacular east of the Rockies." One of the most spectacular sights along the line from Baltimore to the Blue Ridge Mountains was Horseshoe Curve near Sabillasville, Maryland, to the east of Pen Mar. Before trains arrived at Pen Mar Park, a brakeman or conductor would circulate among passengers selling tickets for dinner at the park's famed dining room. For 50¢, an excursionist could have his choice of meats, fresh vegetables, ice cream, and coffee. Former WM (later CSX) engineer Charley Kunkleman recalls the beauty of the area. "I liked very much the trip from Hagerstown to Baltimore. It was all through the countryside, up through the mountains, down through farmland [east of Pen Mar], through small towns. It was really a picturesque trip. I mean it was nice scenery!" (Courtesy David Cline.)

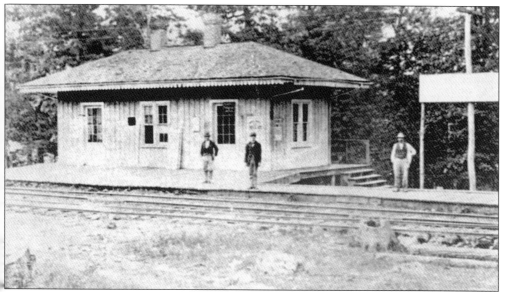

An early Western Maryland railroad station at Blue Ridge Summit is pictured above. A new station (below) was built in 1891 and today houses the Blue Ridge Summit Library. The station was located 69 miles from Baltimore, and the single-fare trip costs $2.07. At one time, Blue Ridge Summit had 16 hotels and boarding houses, the largest being the Monterey Inn and Cottages, which could accommodate 250 guests. (Courtesy Luther Anderson and the *Maryland Cracker Barrel*.)

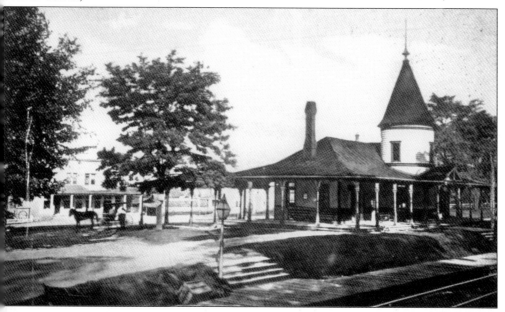

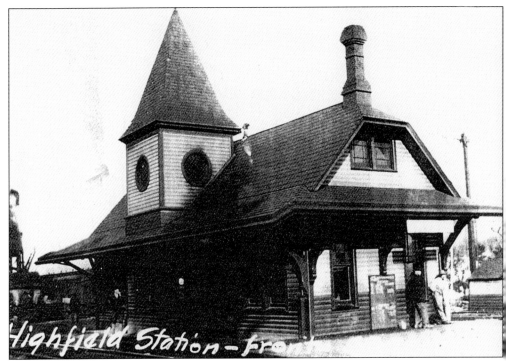

This 1917 photo shows the Highfield Station near Pen Mar. As a youngster, Highfield native Ashby Smith remembers the station burning in the 1920s. "It had an old slate roof, and that kept the heat right in underneath of her. Man, she just burned. They took water out of the water tank to help keep her down." (Courtesy Richard Happel Sr.)

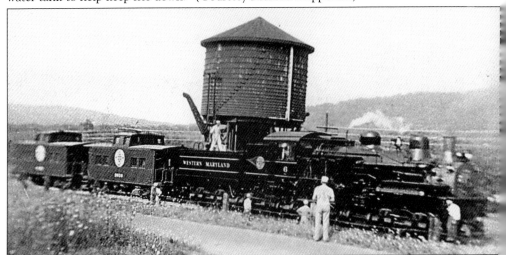

A WM train takes on water at Highfield, 70 miles west of Baltimore, where the Hotel Maryland and four boarding houses could accommodate 177 guests in 1913. A single trip fare from Baltimore to Highfield cost $2.10. Ashby Smith recalls helping his father "clean the excursion cars that came in here. A lot of times there'd be as many as 16 or 17 coaches. You had to sweep the seats off, sweep all the floors, and gather up all the paper." Highfield was also served by the Chambersburg, Greencastle, & Waynesboro Street Railway (trolley), which passed through en route to Pen Mar Park. (Courtesy Richard Happel Sr.)

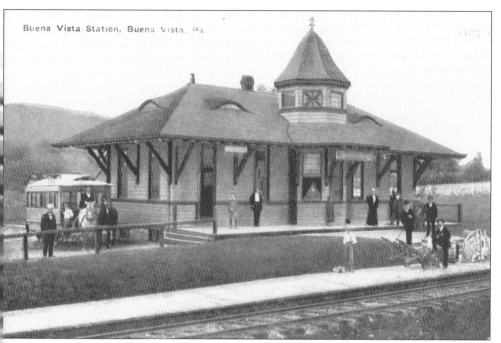

Buena Vista Station, Buena Vista, Pa.

The Buena Vista Spring Station (above) sat 70.5 miles from Baltimore along the Western Maryland Railway, half a mile from Highfield Station to the east and half a mile from Pen Mar Station to the west. The single-trip fare from Baltimore to the station was $2.13. In the immediate area there were 20 hotels and boarding houses, which could handle 585 guests. The grand Buena Vista Spring Hotel accommodated 400 visitors. Later, the Fort Ritchie Station (below) sat on the site of the Buena Vista Spring Station to serve nearby Camp Ritchie, which welcomed Maryland National Guardsmen for the first time in 1927. (Courtesy Virginia Bruneske and the WMRHS.)

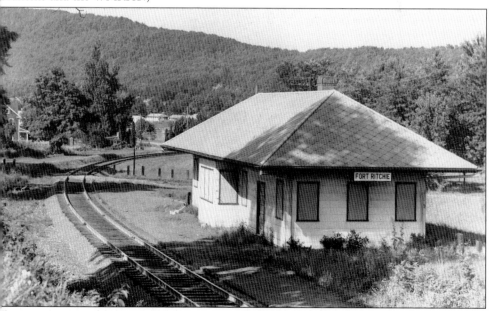

FORT RITCHIE

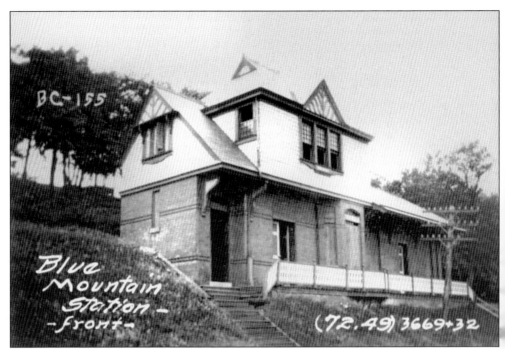

The Blue Mountain Station, 72 miles east of Baltimore, served the Blue Mountain House, which could accommodate 500 guests when it was built in 1883. A passenger riding Western Maryland rails from Baltimore to the Blue Mountain Station would pay a single-trip fare of $2.16. The Blue Mountain Express, which ran only in the summers, was considered the finest train departing from Baltimore's Hillen Station. Wealthy businessmen, who commuted between their Baltimore offices and their summer residences in the Blue Ridge Mountains, filled the plush, gas-lit cars with smoke from their expensive cigars. (Courtesy *Maryland Cracker Barrel* and the WMRHS.)

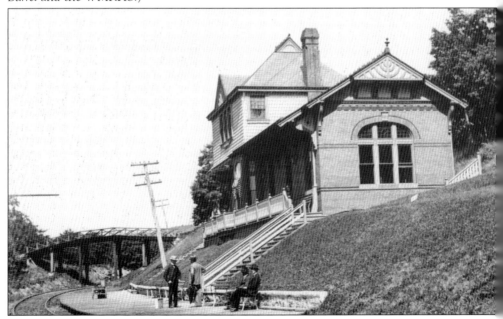

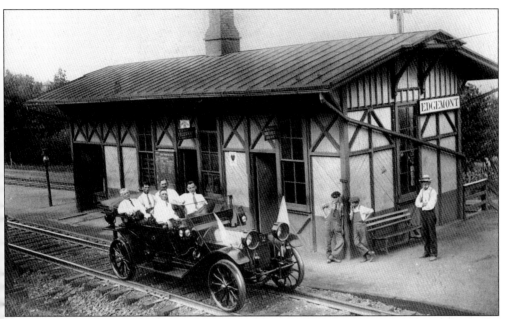

The Western Maryland Railway's Edgemont Station sat four miles west of Pen Mar. The gentleman standing on the right is Daniel Ridenour. The car with special wheels for riding on the tracks carries an inspection team. In the Edgemont area, Shady Grove, Edgeview Cottage, Willow Grove, Mountain Side Cottage, and Blue Mountain View Cottage accommodated 61 guests. (Courtesy Smithsburg Historical Society.)

The Smithsburg Station was three miles west of the Edgemont Station. Smithsburg hosted six hotels and boarding houses. William Kendall remembers the old trains: "They'd do a lot of firing to get up over the mountain. Every time they threw coal in there, cinders would fly. We always had cistern water—always had to clean that out because the cinders would go on the roof and down into the cistern. Every time you cleaned it out, you might have a couple of inches of cinders down in there." (Courtesy Smithsburg Historical Society.)

The Hagerstown Station lay 87 miles west of Baltimore. The original WM station opened on the corner of West Washington and Foundry (now Burhans Boulevard) Streets in 1877. By 1880, four railroads converged on Hagerstown: Cumberland Valley (later the Pennsylvania), Baltimore & Ohio, Norfolk and Western, and Western Maryland. The station above was completed in 1913. By 1941, the WM employed 17,000 workers in Hagerstown. Hagerstown hotels in the early 1900s were the Baldwin, Hotel Hamilton, Franklin House, Central House, Blue Ridge Hotel, and City Hotel. (Courtesy *Maryland Cracker Barrel.*)

In 1979, the main Hagerstown station was renovated to house the Hagerstown Police Department. The first floor of the brick station had featured passenger facilities, a ticket office, a waiting room, and a baggage room. The second floor housed division offices, the superintendent's office, a transportation department, train dispatchers, and a police department. (Courtesy *Maryland Cracker Barrel* and Clyde Roberts.)

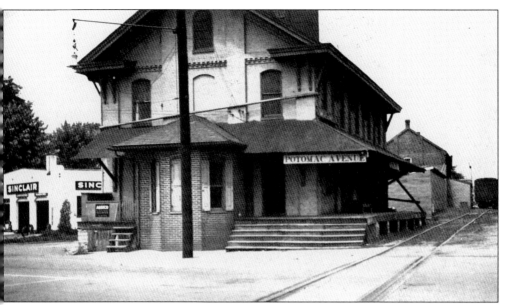

A second WM station was located in the Horst Building on Potomac Avenue in Hagerstown's North End. In 1887, the WM had two passenger stations in the city, a freight station, and two grain elevators. C.M. Horst was the ticket agent and operated the granary. Hagerstown native Janet Dayhoff remembers boarding the train here for the annual Trinity Lutheran Church picnic at Pen Mar Park. (Courtesy *Maryland Cracker Barrel*.)

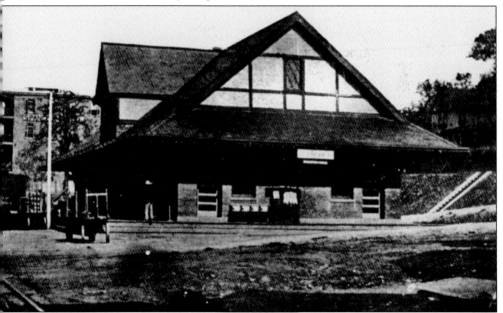

In the early 1900s, Hancock's WM station was a beehive of activity. Born in 1902, Louella Little remembers going to Pen Mar Park: "We always had to get the excursion train that came from Cumberland. We had to be in Hancock at 5:30 in the morning to get it, but we was rarin' to go!" Brothers Gerald and Jack Reed were born in the WM section house at Parkhead, east of Hancock. Gerald reflected that "if you didn't have steam and smoke, you didn't have a railroad." (Courtesy *Maryland Cracker Barrel*.)

Western Maryland Ry. Co.

Non-Transferable Excursion Ticket.

PEN-MAR, MD.

TO

BALTIMORE, MD.

Good for One Continuous Passage
on Train No. 110, date stamped on back

No Baggage Checked *J. G. Krener*

Form-54 Gen'l Passenger Agent.

RETURN

4558

Passengers at the Pen Mar Station below wait to board the train back to Baltimore, taking with them the memories of the trip to Pen Mar Park. A 1936 article in the *Baltimore News American* mentioned "the blind black man who sold postcards at Pen Mar Park and read aloud from a Bible printed in Braille—and the rawboned nags that drew the phaetons and carriages up the steep climb to High Rock—and the delicious chicken dinner in the pavilion—and the dancing to the music of the Waynesboro Silver Cornet Band—and the trip home in the cool of the evening—the young couples holding hands and singing popular songs of the day: 'In the Shade of the Old Apple Tree,' 'Two Little Girls in Blue,' 'On the Banks of the Wabash Far Away.' Ah, those were the halcyon days." (Courtesy of Virginia Bruneske and *Maryland Cracker Barrel*.)

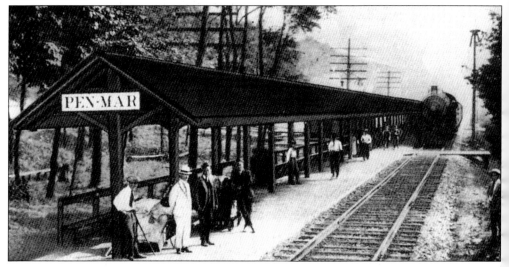

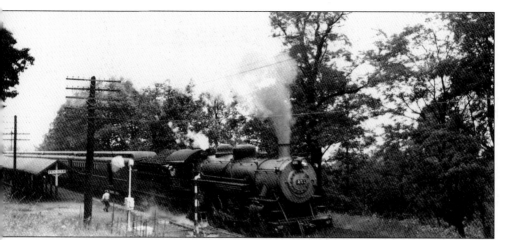

Lines stretched for several blocks as people waited to purchase tickets to Pen Mar Park at the Hillen Station in Baltimore. At times, ticket agents had to push money off the counter and onto the floor, then gather it up and count it after the eager throngs had departed. Now these same excursionists are on their way home to Baltimore, taking with them memories that will draw them back to the mountains again. (Courtesy WMRHS.)

With the closure of Pen Mar Park, winter soon settled over the station. Summer couldn't come soon enough for those who carried memories of fun in the Blue Ridge. For some, however, winter had a charm all its own. Former WM employee John Hamburg notes, "When I think about some of the trips I made on a cold winter night when the moon was shining, and there was snow on the ground, ah, there's just something romantic about being on the steam locomotive." (Courtesy Virginia Bruneske, Wissel Collection.)

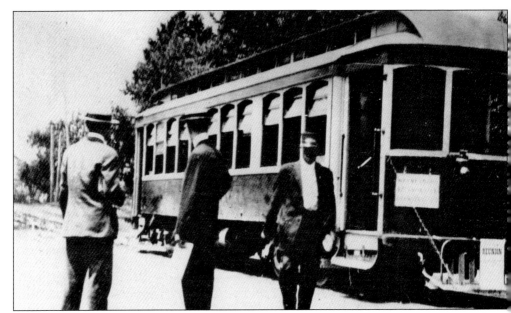

"Trolley Cars Are Coming" was the headline in the July 10, 1902 edition of the Waynesboro Record Herald. The Waynesboro–Pen Mar trolley carried 2,000 riders at 20¢ for a round-trip ticket on November 24, 1903. The trolley was part of the Chambersburg, Greencastle, & Waynesboro Street Railway (CG&W), which had purchased Waynesboro Electric Light & Power Company for its power station. The 26-mile trolley ride from Chambersburg to Pen Mar took 1 hour and 40 minutes. (Courtesy Judy Schlotterbeck.)

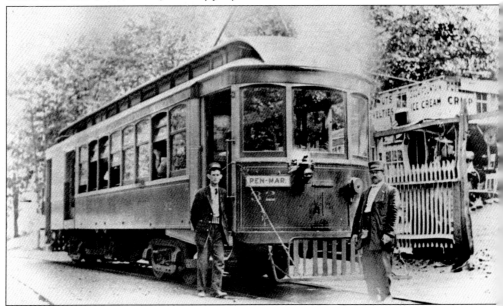

CG&W employees John W. Fitz Sr. and Jim Dale are pictured in front of the trolley at the Pen Mar trolley stop. Kay Whetstone remembers taking the trolley to Pen Mar as a little girl. "We went up on the trolley because we didn't have a car until I was 10 years old. That open trolley was something coming down that mountain. The big, old trolley was kind of bouncy; it had springs, and it would sway. It was something!" (Courtesy Lindy Bumbaugh.)

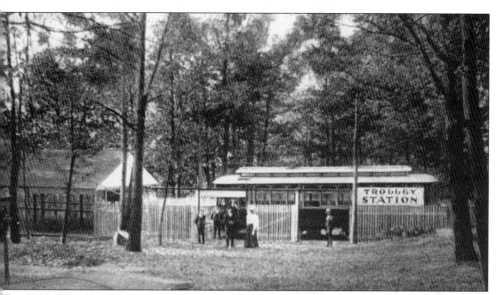

The CG&W trolley left Shady Grove, Pennsylvania, at 5:15 a.m. and arrived in Waynesboro at 6:00 a.m. Twenty minutes later it arrived at Pen Mar. The final departure from Pen Mar to Waynesboro was 11:12 p.m. Richard Happel Sr. remembers, "When the trolley would leave Pen Mar, the first stop was Lake Royer. The next one was Buena Vista, and the next one there was called DeLauter's." There were also stops at Cline's and Blickenstaff's before the trolley reached Blue Ridge Summit. (Courtesy Judy Schlotterbeck.)

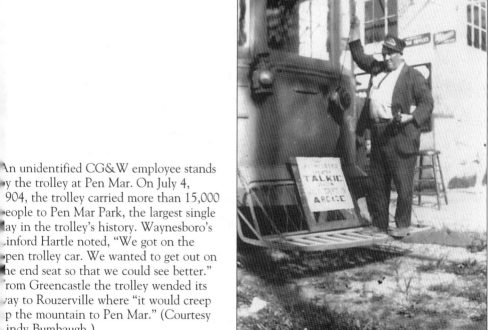

An unidentified CG&W employee stands by the trolley at Pen Mar. On July 4, 1904, the trolley carried more than 15,000 people to Pen Mar Park, the largest single day in the trolley's history. Waynesboro's Linford Hartle noted, "We got on the open trolley car. We wanted to get out on the end seat so that we could see better." From Greencastle the trolley wended its way to Rouzerville where "it would creep up the mountain to Pen Mar." (Courtesy Indy Bumbaugh.)

A battery substation was built near the Pen Mar Station to ensure the trolley had sufficient power to climb the mountain to Pen Mar from Rouzerville. In 1905, the Hagerstown Railway began to extend its line from Hagerstown north to Shady Grove. The trolley proceeded down North Potomac Street and Hamilton Road and through Paramount to Reid, where a single track carried passengers to Shady Grove three miles east of Greencastle to connect with the east-west CG&W trolley. The 11-mile journey from Hagerstown took 30 minutes, and from Waynesboro to Hagerstown the trip took one hour. (Courtesy Lindy Bumbaugh.)

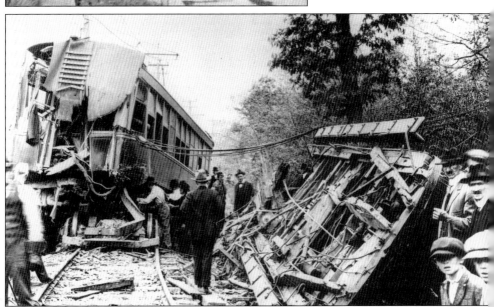

On May 22, 1920, a trolley wreck between Pen Mar and Rouzerville claimed the life of trolley employee R.D. Sefton and injured nearly a dozen passengers. A newspaper account stated that the platform on which Sefton had been standing "had been crushed like an egg shell by the force of the impact and that the front part of the car was entangled with the wreckage of the car ahead." (Courtesy Virginia Bruneske.)

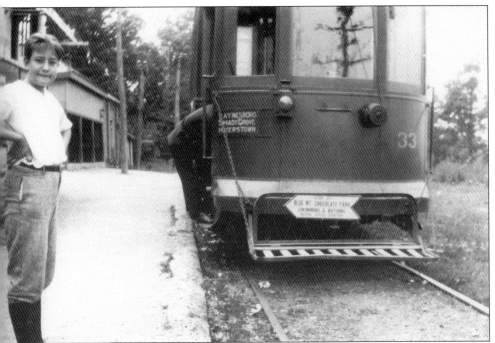

trolley car sits at the station in Pen Mar. As the country emerged from World War I, the line
egan to decline. CG&W ceased operations on January 16, 1932, ending the era of the trolley
or the park. The H&F line from Hagerstown to Shady Grove was discontinued on August 21,
932. Richard Happel Sr. recalls, "I worked on tearing the trolley line up, starting at
ouzerville. I swung a striking hammer that cut the joints [copper ground straps]. Slim Brown
as my partner. I'd cut one joint, and he'd cut one. It was pretty hard work—four or five strikes
er strap." (Courtesy Lindy Bumbaugh.)

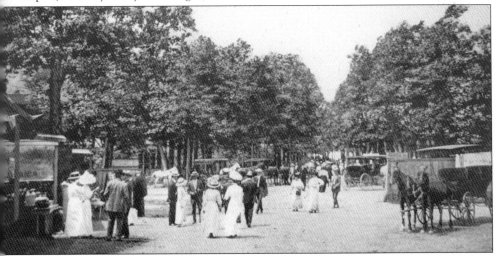

ouise Funk Beachley remembers traveling with her parents to Pen Mar by buggy when she was
oung. A newspaper account relating to the "horseless carriage" in July 1913 noted that 125
eople, including members of the Hagerstown Automobile Club, Inc., made "the monthly run
uesday evening to the Blue Mountain House. All of the 35 automobiles from here made the
un without a mishap." (Courtesy Judy Schlotterbeck.)

Harry Fleigh and friends enjoy a jaunt from Pen Mar Park to High Rock. Former Middleburg, Pennsylvania resident Earl Minnich remembers climbing the mountain to Pen Mar and crossing the old wooden bridge over the Western Maryland tracks at Pen Mar. "We'd try our cars out on it. If you could climb the mountain and get across the bridge in high gear, you had a good car. Dad got a 1938 Chevy. Eight of us got in it; we just made it over the bridge." (Courtesy Judy Schlotterbeck.)

O.D. Sherley and a group of friends are "goin' to Pen Mar" in a Marmon touring car built shortly before 1920. Sherley is in the front seat at left. Don Werdebaugh recalls, "My brothers Dick and Tom used to park the cars [on their uncle's property across the street from the park] for 25¢. We'd say, 'Park the car in the shade' because we had a lot of trees." (Courtesy *Maryland Cracker Barrel.*)

Two

ADVENTURIN' AT
PEN MAR

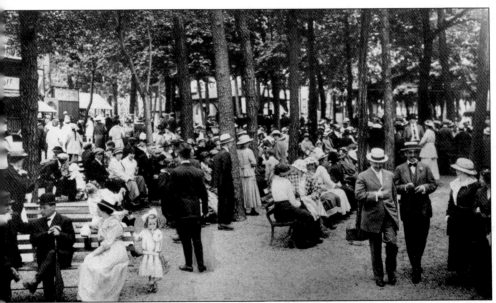

cool breeze and an enchanting view were reason enough to head for the Blue Ridge on a
ifling summer day. The opening of Pen Mar Park on August 31, 1877, was the "icing on the
ake" for literally millions of visitors for the next 65 years. With the mountain temperatures
·portedly 10 degrees cooler than on the floor of the Cumberland Valley below, it is no wonder
1at people could wear their "Sunday best" and still have a memorable day at the park.
Courtesy Judy Schlotterbeck.)

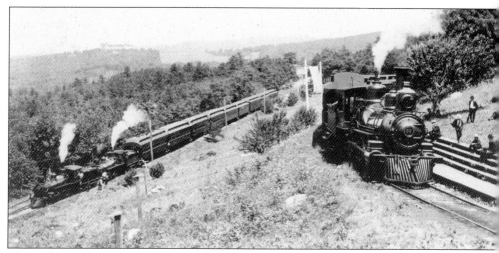

The creation of Pen Mar Park was the brainchild of the Western Maryland Railway, so it logical that the primary mode of travel to the Blue Ridge in the infancy of the park was via th railroad. In the photo above, a westbound train with eight passenger coaches is pictured on th left, while to the right a WM engine can be seen bringing visitors into the park on a siding jus beneath the overlook. In the 1906 Western Maryland Railway photo below, some park patron enjoy the picturesque scenery while others are following the main promenade into the par (Courtesy WMRHS and the *Maryland Cracker Barrel.*)

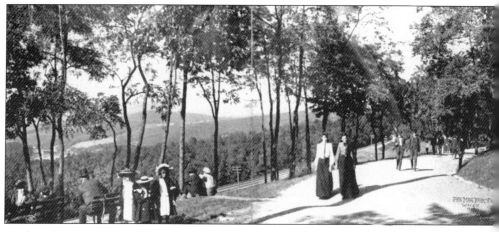

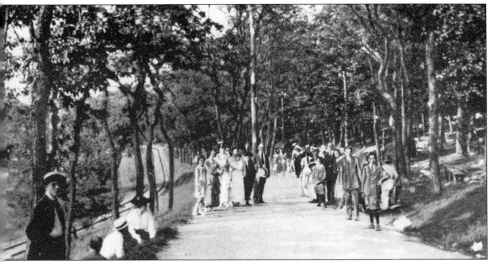

the photo above, visitors who arrived at Pen Mar via the train or the CG&W trolley walk the main promenade to the park. The railroad siding that brought passengers directly to the rk is at left. The Western Maryland carried 6,000 more passengers to the Maryland mountain sort in the summer of 1909 than in any previous year. Riders included not only those from aryland and Pennsylvania, but also New Jersey and New York. By 1929, the WM had moved the siding into the park. The picture below shows the absence of the siding, as scores visitors who have just arrived by train are making their way up the promenade. The Pen Mar ation can be seen at the left. (Courtesy *Maryland Cracker Barrel* and Judy Schlotterbeck.)

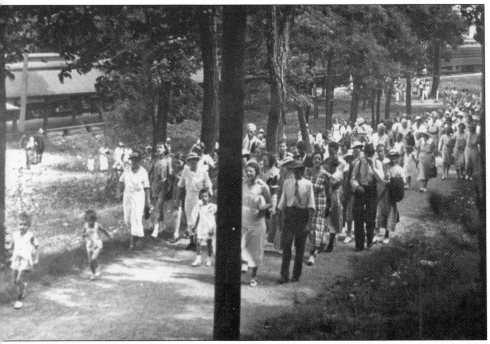

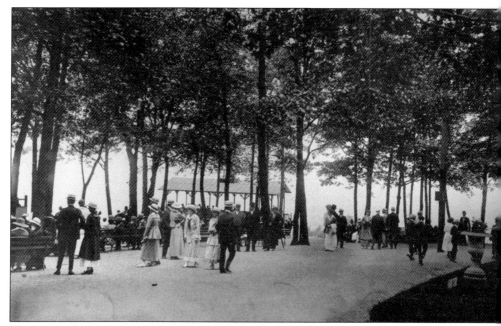

The overlook at Pen Mar Park can be seen in the background above as visitors enjoy a leisure day at the park. In the early 1900s, the Western Maryland Railway removed small grass plot near the dance pavilion (left) so more benches could be placed for the enjoyment of patron. Dancers had used the grassy knolls as a resting place. Below, visitors can be seen takin advantage of some of those benches while others stand to converse with friends. For years, th park opened on Decoration Day (Memorial Day) and remained open until Labor Da (Courtesy Judy Schlotterbeck.)

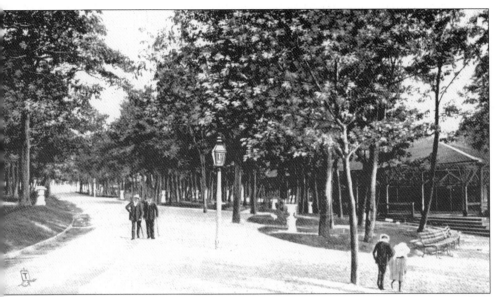

rain-alcohol lamps lighted the promenade until 1906, when electric lights were installed. housands visited Pen Mar for a "one-day honeymoon," but a 1902 wedding was the result of chance meeting at the park. A young lady and friends from Hagerstown were visiting the park hile camping nearby. A young man from New York snagged his trousers and asked the young oman for pins to fasten the rent. She had none, but he accompanied her to the campsite, here she found some for him. The rest is history. (Courtesy Virginia Bruneske.)

he walkway through Pen Mar Park—known as the Avenue—was 40 feet wide. On the left, a gn promoting Everybody's Day hangs from the movie theater. Western Maryland general assenger agent F.M. Howell placed an electric fountain close to the flagpole near the overlook 1906. The fountain had numerous electric lamps "by which the water will be illuminated in variety of colors. It is expected to prove one of the most attractive features of the park." Courtesy Virginia Bruneske.)

39

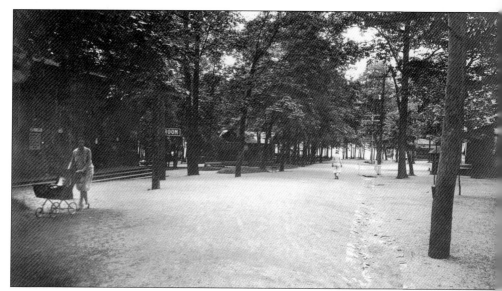

Walking on the Avenue toward the overlook, one can see the Pen Mar Dining Room on th left. Across from the dining room next to the movie theatre was a concession stand famous f its nickel ice cream cones, 10¢ sundaes, hot dog sandwiches, and homemade soup. Excursionis coming to the park via train or trolley could check their picnic baskets at the concession stan for a dime. (Courtesy Virginia Bruneske.)

The Point View Hotel can be seen at the right just above the entrance to the park. In 190: W.B. Littleton test drove his new Rambler to Pen Mar and reported no problems, although th road from Waynesboro to Pen Mar was rough from recent rains. On the return trip, Littleto traveled from Leitersburg to Hagerstown in 16 minutes. During the drive, Littleton came upo a horse, who was startled by the car and broke its harness. Littleton helped mend the harne: before continuing. (Courtesy Virginia Bruneske.)

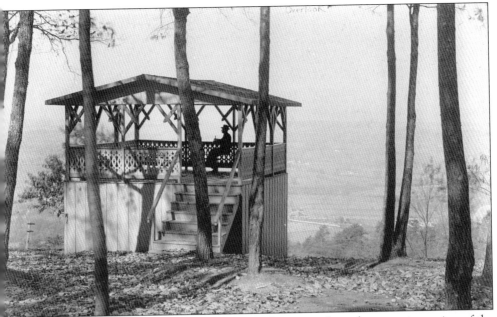

Above is the original overlook at Pen Mar Park. Below, several gentlemen enjoy a view of the Cumberland Valley from the park's second overlook, which replaced the more ornate structure sometime before 1916. For Waynesboro native Jim Brinkley, a trip to the Blue Ridge resort offered one of the simple pleasures of life: sitting and viewing the valley below. "I had a big time! You could sit on the edge and look out toward Waynesboro. Another simple pleasure was the nice breeze." As dusk settled over the park, visitors could watch as lights across the floor of the Cumberland Valley switched on while strains of "When Day Is Done" or "Goodnight Sweetheart" played in the background. (Courtesy Virginia Bruneske.)

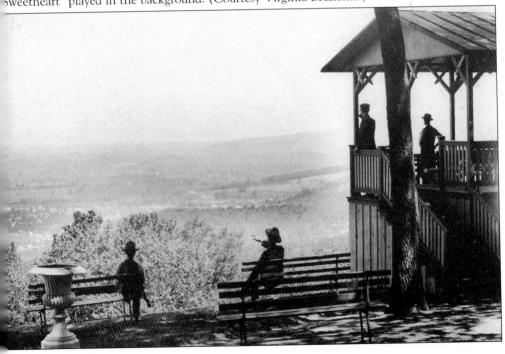

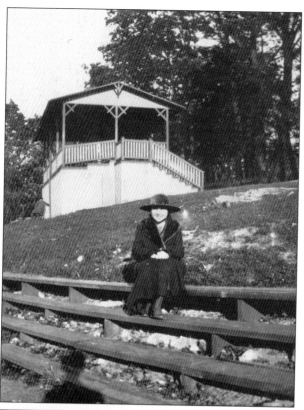

Ruth Whitmore (left) sits near the Western Maryland siding at Pen Mar. Miss Whitmore was 12 when she began selling tickets at the park's movie theater. Below, excursionists board coaches home after a day in the park. A newspaper account in the early 1900s cites that there were "fully 1,000 persons at the station to get aboard and only five cars to haul them. . . . A rush was made by the crowd to get aboard and in the excitement ladies lost their hats and children were knocked down. . . . [There] were 18 coaches and 2 engines on the last train down from the Park to Hagerstown." At nearby Edgemont, 9 coaches were detached to make up a train bound for Hagerstown "while an equal number were taken to Chambersburg, [the passengers] not being told . . . that the cars they were occupying were not for Hagerstown." (Courtesy Virginia Bruneske and Judy Schlotterbeck.)

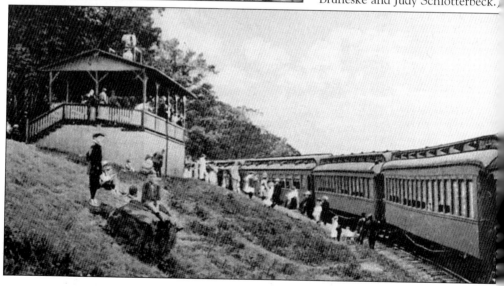

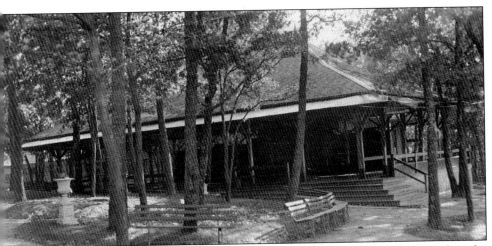

One of the earliest structures at Pen Mar Park was the dance pavilion (above), located on the west side of the promenade. The original pavilion was moved from the Western Maryland Railway's Greenwood amusement park in Baltimore County. It was open on the sides with benches along the perimeter for tired dancers or those who just wanted to sit and listen to the music or watch the dancers. The structure was enlarged twice until it reached a length of 92 feet. An account is told that several young ladies placed their lunches in the pavilion, and in the evening when they went to retrieve the lunches "for friends expected to lunch with them, the boxes were gone—vamoosed—stolen. The boxes contained the choicest portions that had been saved from earlier in the day." (Courtesy Virginia Bruneske.)

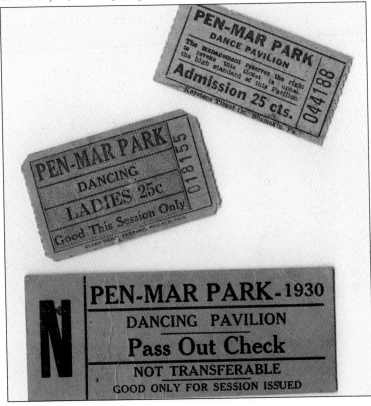

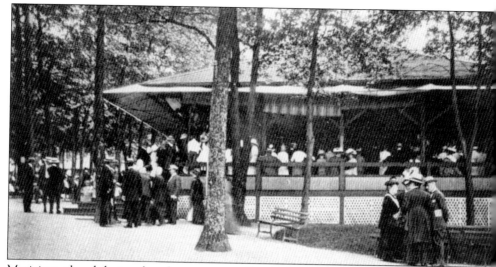

Musicians played during the afternoons as well as in the evenings at the dance pavilion. For many years two concerts were given on Sundays, but that changed in 1936 when dancing was permitted on the Sabbath; the concerts were then replaced with dance music. Lighting was originally provided by four large brass kerosene lamps hung from the ceiling. In 1906, electricity was installed in the park, negating the use of kerosene lamps. (Courtesy Judy Schlotterbeck.)

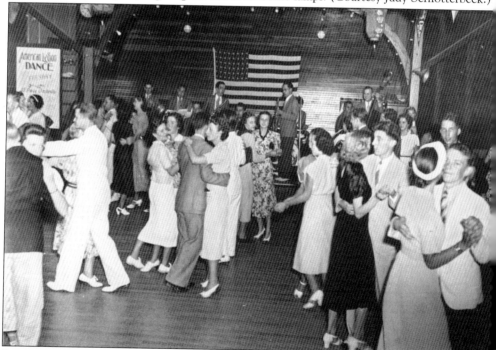

During World War I, soldiers from Camp Colt in Gettysburg, where Capt. Dwight D. Eisenhower was serving, were regulars on the dance floor. Girls from nearby Camp Louise—"a camp for Jewish girls"—also took advantage of the park's dance pavilion. Nancy Gehr remembers picnics in the park with the Hagerstown Church of the Brethren from the late 1930s until the start of World War II. "After supper we got a big bang out of watching the older ones [19- and 20-year-olds] dance." (Courtesy Judy Schlotterbeck.)

CONCERT PROGRAMME

-BY THE-

PEN-MAR BAND,

PROF. JOHN ZIEGLER, Director

1. March - Coronation....................Kretschmer
2. Overture - The Fairy Queen...............Tobani
3. Selection - The Fortune Teller..........Herbert
4. Medley - Rag Melodies....................Mackie
5. Waltz - Dreams of Childhood.........Waldteufel
6. Overture - La Dame Blanche............Boieldieu
7. Selection - The Serenade................Herbert
8. Song - Cavalry...........................Rodney
9. Fantasia - Alpine Horn.....................Proch
10. Medley - The Cracker Jack................Mackie
11. Selection - The Jolly Musketeer.........Edwards
12. March - La Reine de Sabo................Gounod

ORDER OF DANCING

Monday, Wednesday, Friday

PROF. J.J. WHITE, Director of Dancing

1. Two-Step - Ma Rag-Time Baby...............Stone
2. Waltz - Confidence...................Waldteufel
3. Two-Step - Hands Across the Sea...........Sousa
4. Lanciers - A Little of Everything.......Mackie
5. Waltz - Because..........................Mackie
6. Two-Step - Georgia Camp Meeting..........Mills
7. Waltz - Dear College Chums...............Harris
8. Lanciers - The Fortune Teller...........Herbert
9. Two-Step - The Matinee Girl................Hall
10. Waltz - Love's Melody.....................Orth
11. Two-Step - Charlatan.....................Sousa
12. Lanciers - Brian Boru..................Edwards

Soon after Pen Mar Park opened in 1877, the Pen Mar Orchestra became an annual tradition at the summer resort. Prof. John Henry Ziegler, from Baltimore, led the 10-member orchestra, all professional musicians: George Bauman, Otto Berger, John Geyer, Charles Kaspar, William Kreiger, Fritz Paff, William Rosenberger, George Ross, Ziegler's son Henry, and Ziegler himself. Around 1900, Ziegler suffered a stroke while his orchestra was playing at the park. Shortly thereafter Ziegler passed away, and the baton was passed on to his son. (Courtesy Virginia Bruneske.)

45

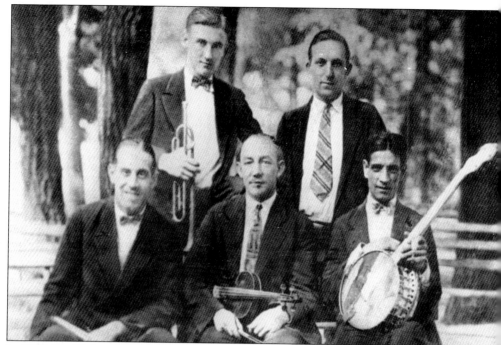

In 1905, Prof. John C. Bohl, John Henry Ziegler's grandson, became the new leader of the Pen Mar Orchestra. Orchestra members in this 1925 photo are, from left to right, (front row) Charles "Chick" Wright, Kurt Alt, and Frank Carozza; (back row) Jack Schaffer and Jerry Thalheimer. The orchestra played from 9:00 to 10:00 a.m. on the Blue Mountain House' porch, from 11:00 a.m. until 7:00 p.m. in the park, and from 8:00 to 10:00 p.m. in the Blue Mountain House. (Courtesy Judy Schlotterbeck.)

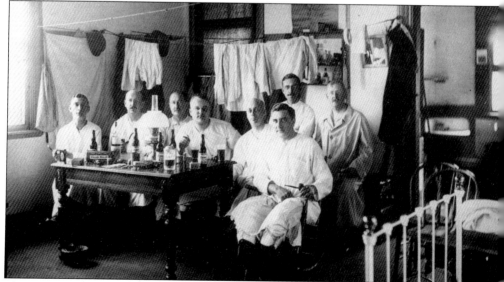

The second floor of the Blue Mountain Station, built in 1883, was the summer home of the Pen Mar Orchestra for a number of years. Melinda Spencer, matron for the railroad, prepared the room and took care of their laundry for 12.5¢ an hour. Professor Bohl's orchestra gave its final performance at Pen Mar Park in the summer of 1926. (Courtesy Judy Schlotterbeck.)

46

arl Simpson's Orchestra succeeded ohl's musicians at Pen Mar Park eginning in 1927 and was on center age at the park through the 1930 eason. The photo on the right shows impson's Plantation Band in 1930. he music provided by the band was velier than park visitors had known reviously. Some of the new songs ere "Make Believe," "Why Do I Love ou?," and "Stay In Your Own Back ard." (Courtesy Judy Schlotterbeck.)

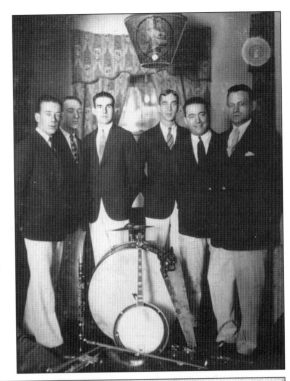

With the onset of a new summer eason at Pen Mar Park in 1931, the el Smith Orchestra replaced impson's band and became a mainstay or music lovers at the park until its emise following the 1942 season. mith's widow, Ann, stated that her usband "didn't graduate from high chool [Waynesboro] until 1932. They layed there until they closed the park n 1943." (Courtesy Mrs. Zel Smith.)

PEN MAR PARK

OLDEST MOUNTAIN PARK IN THIS SECTION

Wonderful Scenic View of Cumberland Valley

Dance Nights: Wednesday, Thursday, Saturday, Sunday. JULY FOURTH, both Afternoon and Night

Music By-Zel Smith's Ever Popular Dance Band

Amusements including Roller Coaster, Merry-Go-Round, Min-
iature Steam Railway, Pony Track, Horse Shoe Pitching, and
Children's Playground.
Free Parking Every Day Except Sundays and Holidays.
A Swell Place to Hold your Picnics.

PEN MAR PARK

Scene of Church, Sunday School, Fraternal and Family Reunions

Join the Happy Daily Throng at This Mountain Pleasure Park

DANCING

In the Spacious Open-Air Pavilion

Featuring

PENN-ACES ORCHESTRA

Famous Meals At Pen Mar Dining Room

Restaurant Service

Free Children's Playground Shady Picnic Grove

Delightful Drives to All Points of Interest

Bowling and Skee Ball Moving Pictures Merry-go-round

Ample Parking Space

Abundance of Hotels and Cottages for Guests

This 1932 advertisement for Pen Mar Park touts Zel Smith's Penn Aces Orchestra in the open-air dance pavilion. Smith was familiar with Pen Mar as a youngster, since his aunt owned a cottage in the area. In the summer of 1929, the future bandleader sold tickets at the dance pavilion. At the Knights of Columbus Reunion at the park on Thursday, August 18, 1932, Maryland governor Albert C. Ritchie was the featured speaker. (Courtesy Mrs. Zel Smith.)

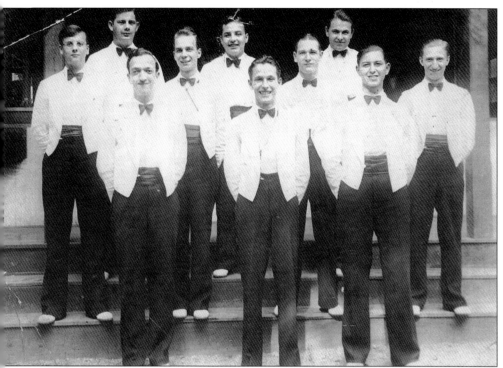

The original Pennsylvania Aces are, from left to right, (front row) Walter Sheldon, band leader Zel Smith, and Marty Goldstein; (middle row) John Knepper, Charles Stoner, Nooks Naugle, and Alton Wingert; (back row) Don Wishard, Edward "Bud" Kauffman, and "Teen" Riley. The 1936 contract specified an "orchestra of 8 men Monday, Tuesday, and Wednesday; and 10 men Thursday, Saturday, and Sunday" for $145 a week. (Courtesy Mrs. Zel Smith.)

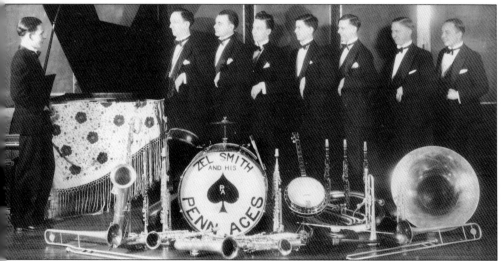

Zel Smith's Penn Aces are seen in this 1931 photo. A letter written by one of the band's original members, Gil Stitely, reveals that the "pay as I recall was $25 per week and room and board each. We ate at the Park restaurant and slept in the little structure at the lower end of the park. . . . Those huge 900 locomotives shook the mountain and awoke us many a night until we got so accustomed to them they no longer bothered us." (Courtesy Mrs. Zel Smith.)

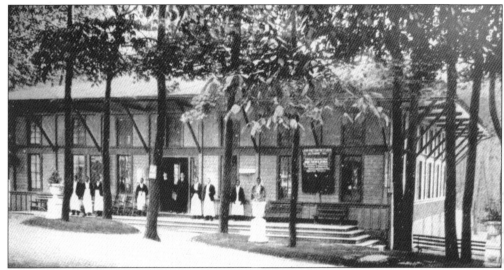

One of the early structures to appear at Pen Mar Park was the Pen Mar Dining Room, located along the Avenue. The dining hall was built by the Western Maryland Railway at a cost of $5,000 and was capable of seating 450 guests. A large staff of African-American chefs and waiters attired in black suits, white shirts, and black bow ties served guests. (Courtesy Judy Schlotterbeck.)

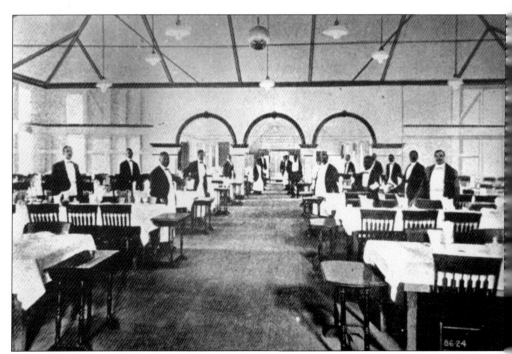

John Emory Crout served as the first manager of the Pen Mar Dining Room, which soon became famous along the Eastern Seaboard for its 50¢ dinners. When Crout died, his son Jason assumed management of the dining room until 1915, when John J. Gibbons Sr. became the manager. The annual lease was $900, payable to the Western Maryland. Rooms above the main dining hall served as living quarters for restaurant employees and members of the Pen Mar Orchestra. (Courtesy Judy Schlotterbeck.)

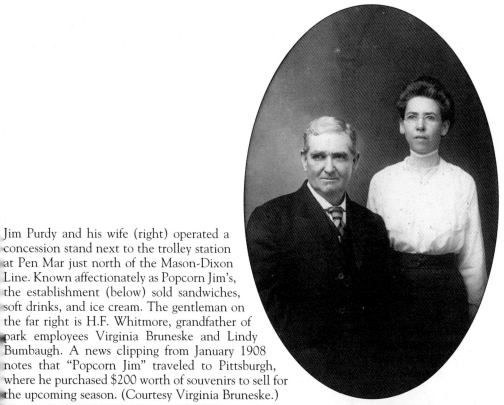

Jim Purdy and his wife (right) operated a concession stand next to the trolley station at Pen Mar just north of the Mason-Dixon Line. Known affectionately as Popcorn Jim's, the establishment (below) sold sandwiches, soft drinks, and ice cream. The gentleman on the far right is H.F. Whitmore, grandfather of park employees Virginia Bruneske and Lindy Bumbaugh. A news clipping from January 1908 notes that "Popcorn Jim" traveled to Pittsburgh, where he purchased $200 worth of souvenirs to sell for the upcoming season. (Courtesy Virginia Bruneske.)

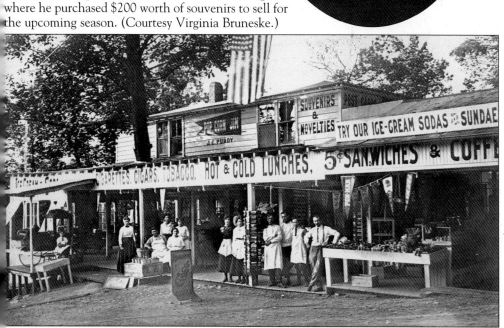

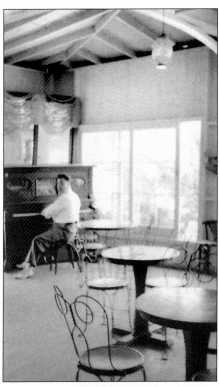

Paul Wissel sits at the piano in the dining area of Popcorn Jim's, where the player piano would come to life for a nickel. For a time, the restaurant was also the site of the Pen Mar Post Office, where sisters Helen and Ruth Whitmore served postal patrons. (Courtesy Lindy Bumbaugh.)

Ruth Whitmore Werdebaugh sits in front of a lunch stand outside the park. Next to the Pen Mar Dining Room was a soda fountain owned by Leon Werdebaugh, who also owned the lunch stand. As Werdebaugh readied the soda fountain, he would bake as many as 20 hams. Park patrons consumed up to a ton of hot dogs a day over the weekend, and on Sundays it wasn't uncommon to see 500–600 gallons of ice cream disappear courtesy of hungry excursionists (Courtesy Virginia Bruneske.)

The points on this map are numbered as follows: 1. Pen Mar Dining Room; 2. photo studio; 3. roller coaster; 4. movie theatre; 5. carousel and penny arcade; 6. Dance Pavilion; 7. concession stand; 8. original miniature train station; 9. relocated miniature train station; and 10. scenic overlook. (Courtesy Washington County Buildings, Grounds, and Parks Department.)

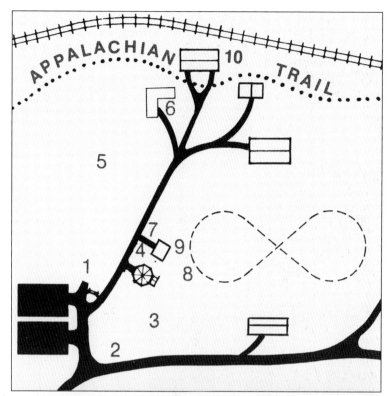

Pictured with a pony at Pen Mar Park are, from left to right, Helen Frysinger, Virginia Laspe, "Fats" Punt, Annamae Keenan and her unidentified brother, and Eddie Ditch Jr. For a nickel, visitors enjoyed the pony and goat track—the first amusement at the park. Eddie Ditch Sr. owned the amusement for more than 35 years. Don Werdebaugh remembers working for Ditch at the attraction: "We'd walk the little kids around the pony track. They even had goats with carts hooked to them. After the park closed in the fall, we'd ride the ponies down to farms in the Edgemont Road area." (Courtesy Virginia Bruneske.)

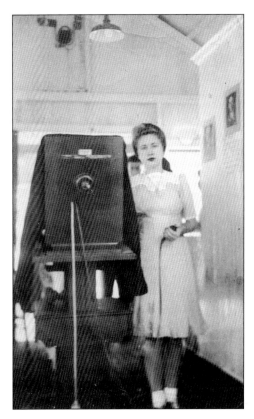

In 1902, a photographer's studio opened in Pen Mar Park near the roller coaster. Virginia Bruneske, who still lives above the park, is pictured working in the studio, which initially used the tintype process. As Mrs. Bruneske reflected on her years at the park, she observed, "I enjoyed those years. You met a lot of nice people. We used to see Gov. [Albert] Ritchie. He'd always come over and ride the train." (Courtesy Virginia Bruneske.)

Lorraine "Rae" Grossnickle Sipes became the last owner of the park's photographic studio when she purchased the business from Charles D. Karns. Rae operated the studio until the park closed after the 1942 season. She then opened a studio in Waynesboro, which operated under the name of Pen Mar Studio. (Courtesy Virginia Bruneske.)

Studio patrons had the option of three backgrounds: High Rock Observatory, Devil's Race Course, or a plain curtain. Hilda Mae (Gordon) Reed selected the observatory as her background choice sometime prior to 1928. Virginia Bruneske spent four summers working at the photographic studio. Working from 8:00 a.m. until midnight seven days a week, Virginia's starting salary was $4 a week. Initially, she sold pictures, but later she was the official park photographer. (Courtesy Mr. and Mrs. William E. Reed Sr.)

In 1913, Guy Alfred Staub and his new bride, Annie Mummert Staub, had their picture taken while on their honeymoon. Their daughter Anna Zile recalls visiting Pen Mar Park in 1935. "What a special treat that was! My oldest brother Norman rode a chestnut colored pony, and our younger brother Bill rode the goat cart. I think the memories of Pen Mar Park remained so vividly in my mind all these years because our dear mother died January 6, 1936. I cling to these happy memories of Mama." (Courtesy Anna Staub Zile.)

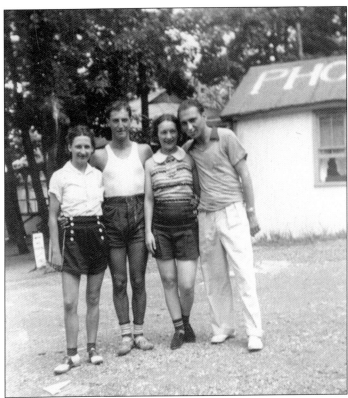

Virginia Rohrer Ludwig and her cousin Jane Rohrer Norman are seen with two unidentified young men near the photographic studio. In the early 1920s, Washington, D.C. native Albert Nelson Deal visited the park with some friends. He met Pauline Zeigler, whose father operated a tailor shop in Hagerstown. It didn't take the young man long to move to Hagerstown, where he worked for the Western Maryland. In 1928, he married the young woman he had met at the park several years earlier. (Courtesy Virginia Ludwig.)

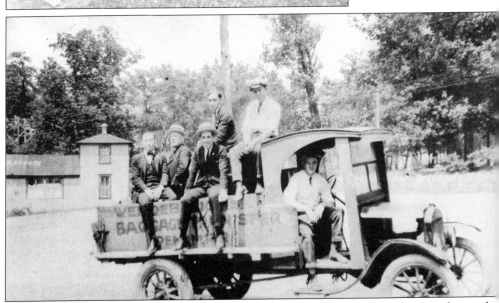

A truck driven by Dean Werdebaugh is pictured on the Avenue with the photographic studio in the background. The studio had sleeping quarters upstairs. One of the employees who lived at the studio, Virginia Bruneske, remembers Mr. Karns going to nearby Camp Louise, where he would take pictures of the camp counselors. "We'd make the pictures in bunches and take them over there. They had a little store over there, and the girls would buy pictures of their counselors." (Courtesy Virginia Bruneske.)

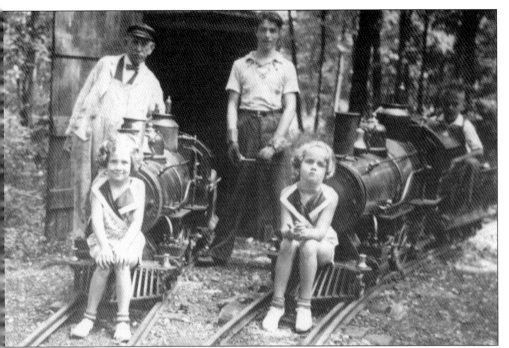

In 1904, a miniature train owned and operated by William N. Fleigh, a WM engineer, opened at the park. Brothers Harry and Bob Fleigh served as the conductor and engineer, while their mother, Mrs. Mary Elizabeth Fleigh, sold tickets. A ticket cost 5¢, but later the price was raised to a dime. Mr. Fleigh bought an engine, tender, and three open cars for $1,500. Mr. Fleigh (left) is pictured with Paul Frazer, who walked from his Blue Ridge Summit home to work on the miniature railroad. The girls are unidentified. (Courtesy Judy Schlotterbeck.)

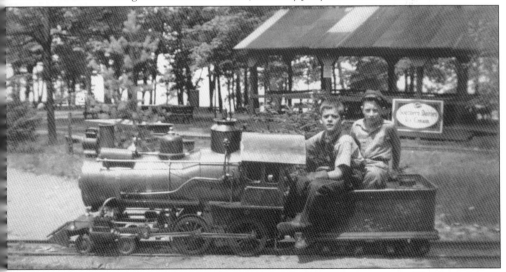

Gene Werdebaugh (left) and Eddie Ditch enjoy Mr. Fleigh's miniature train. The locomotives were models of full-sized engines. Each one burned hard coal, had a headlight, a brass bell, and a whistle, and measured three feet from the rail to the top of the stack. Harry Fleigh recalled that on a busy day as many as 2,000 people would take the five-minute ride. (Courtesy Virginia Bruneske, Wissel Collection.)

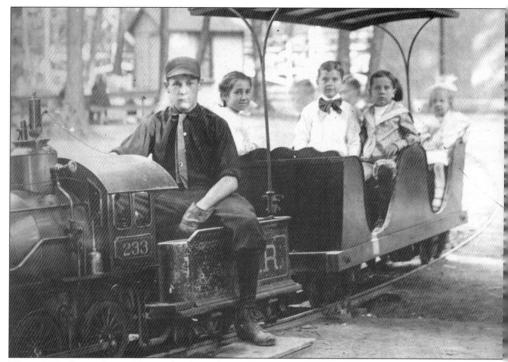

This 1912 photo shows Harry Fleigh at the controls of the "Little Wabash." The lad in the bow tie is Edgar L. Hildebrand, and next to him is his brother Carl. On the tender were the letters "L.W.R.R.," which stood for Little Wabash Railroad, the name Mr. Fleigh selected for his operation. The passenger cars were tan and green with a green-fringed roof. Eight adults or a dozen youngsters could ride in each car. (Courtesy Lola Ann Hildebrand McBee.)

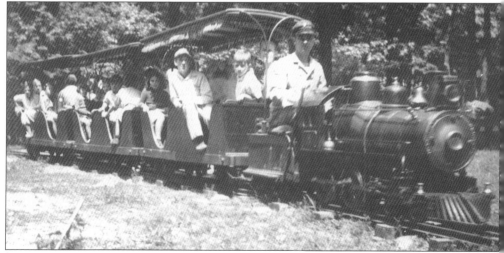

Former Waynesboro optician Joe Baird fondly recalls, "I always liked to ride that little train. It only cost you a nickel then. I guess they took you two rounds around the track. Then you went through a tunnel, the little building where they kept the little cars and locomotives." Paul Frazer noted, "Sometimes at night on the last trip, someone would put a coal bucket on the tracks. You hit that coal bucket, and the engine would jump the tracks, but no one got hurt!" (Courtesy Washington Square United Methodist Church, Hagerstown.)

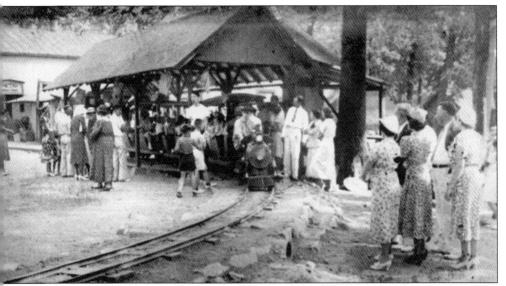

The "Little Wabash" is ready to leave the station for the five-minute ride on the figure-8 track about a quarter-mile long. Harry Fleigh commented that in its initial year of operation the track was straight. "We would puff to the end of it, then back to our terminal. The second year Dad designed a figure-8 track." (Courtesy Judy Schlotterbeck.)

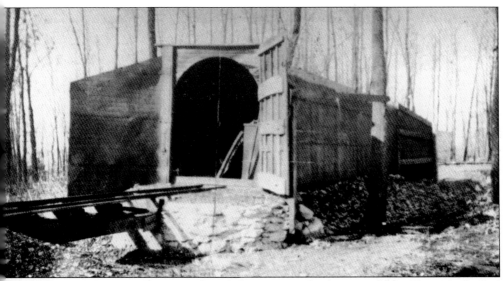

Bob Carter, who became "engineer, second class" to Mr. Fleigh, remembers, "The tunnel acted as a dark thrill part of the train ride during the day, and at night we locked the trains in the tunnel with a heavy, locked door on each end of the tunnel." In the mornings "a fire [was built] in the fire chamber . . . heating the water in the engine's boiler to the boiling point to make steam. Then the wood fire would make way for coal until there was a hot coal fire in the boiler bed that had to be maintained by the engineer all day long." (Courtesy Judy Schlotterbeck.)

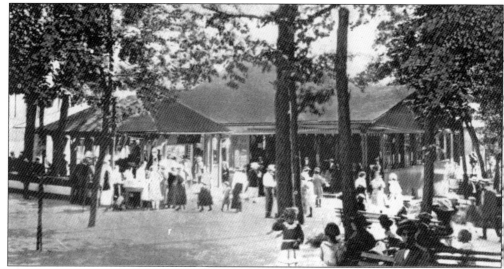

Around 1907, a 77-foot by 125-foot carousel appeared near the Pen Mar Dining Room. The building, owned and operated by Mr. and Mrs. William Libby, also housed a "country store," shooting gallery, penny pitch, and funny mirrors. Mrs. Bruneske spent two summers working at the "country store," a game played by spinning a wheel. "Players hoped that the wheel would stop on the number on which they had placed their money. Various prizes included stuffed animals, glassware, and kewpie dolls." (Courtesy *Maryland Cracker Barrel.*)

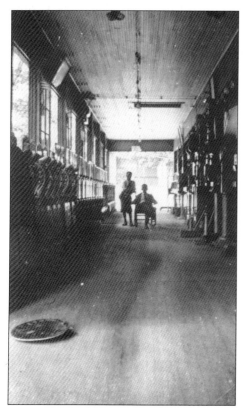

Henry Whitmore and Lee Rodgers are pictured in the penny arcade, which had three-dimensional movie machines that viewers peered into as they cranked the handles. Hagerstown area resident Nancy Harbaugh Gehr recalls watching some of those movies. She notes that some of those movies were "risqué, but not by today's standards." Elizabeth Zimmerman Bragunier remembers, "The shock machine turned a handle, and the faster it was turned the more the shock." (Courtesy Virginia Bruneske.)

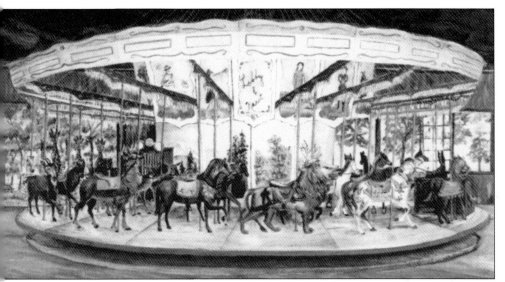

Very few pictures of the carousel are available today. An oil painting of the carousel done by Virginia Bruneske is the primary memory of the ride. Pen Mar area resident Luther Anderson remembered the carousel as the "amusement of choice when you had the money." Richard Happel Sr. recalls, "But I got dizzy going around there." As a youngster Lindy Bumbaugh worked in the carousel building. "I put in rings one summer. The last year that I worked there, I collected tickets at the carousel." (Courtesy Virginia Bruneske.)

The carousel staff c. 1936 is, from left to right (front row) Richard Fox, Louise Spangler, Russell Spangler, Park Spangler (Russell's father), Nettie Ripple, Laura Ripple, Charles Eberly, Earl Punt, John Honodel, and Allen Martin; (back row) Elwood Bumbaugh, Creston Bumbaugh, George Hahn, Robert Miller, Harold Laspe, Lloyd Cline, Warren Eberly, and Mike Zimmerman. Punt operated the ride from 1930 through the 1942 season. An organ in the center of the circle supplied the calliope-type music. (Courtesy Lindy Bumbaugh.)

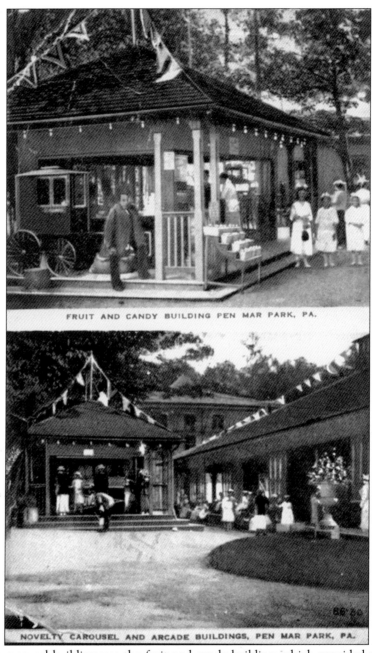

FRUIT AND CANDY BUILDING PEN MAR PARK, PA.

NOVELTY CAROUSEL AND ARCADE BUILDINGS, PEN MAR PARK, PA.

Next to the carousel building was the fruit and candy building, which provided park visitors with yet another venue to satisfy their appetites. In the summer of 1942, Pen Mar residen Charles Trite worked at the carousel "putting rings on the arm. Every 15 or 20 rings was a brass ring. The others were steel rings." Trite's pay for the park's final season was 50¢ a day. One of the challenges of the ride was to catch a brass ring hung from a slotted arm near the carousel Catching the brass ring entitled the winner to a free ride. For Jim Brinkley the attempt to capture the brass ring was unusually difficult. "I was left-handed. It was pretty awkward for me to try to get the brass ring" since the carousel traveled in a counterclockwise direction (Courtesy Virginia Bruneske.)

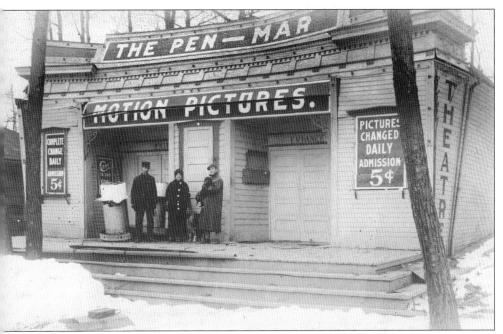

In the early 1900s, a movie theatre with wooden folding chairs became a new attraction along the Avenue. Black-and-white silent movies were shown on hand-cranked projectors. Walter Stuempfig was the original owner. In 1911, William Libby assumed ownership, until Billy Potteroff, who also owned a dry cleaning business at Pen Mar, became the new owner in the late 1920s. Richard Happel Sr. recalled, "When the theatre opened, they had a Victrola that sat out front. They'd put a record on, and they'd crank it up." (Courtesy David Cline.)

A newspaper account in the spring of 1909 notes that "one of the largest roller coasters ever built is being erected and will be completed by the opening date. It gives a ride of over half a mile, with exciting curves." C. Rarick of New Brighton, Pennsylvania, was the original operator of the ride, also known as the "racer dip." Harry Ditch, who at one time worked at the roller coaster, later became the owner. (Courtesy Virginia Bruneske.)

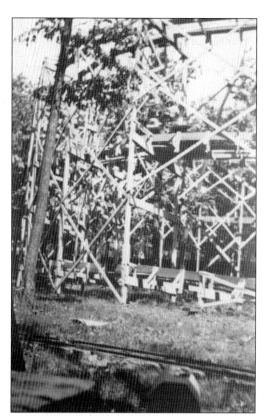

In the photo below, the miniature railroad station frames the roller coaster at the right. For a dime, thrill seekers could ride the "racer dip" after glancing at the sign adjacent to the ride's entrance: "Hold your hat and don't stand up!" Commenting on the roller coaster, Luther Anderson said, "I rode that many a time—not too scary. It shook a good bit, you know. It was wooden." This was reason enough each morning to prompt Harry Ditch to take his hammer and nails and traverse the ride searching for loose boards. (Courtesy Judy Schlotterbeck.)

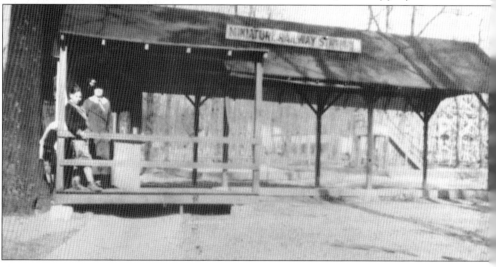

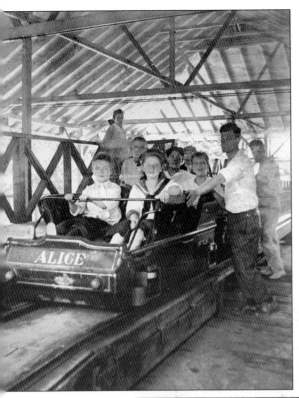

John Donahue, Harry Fleigh, and Bob Fleigh (below) are pictured on Pen Mar Park's roller coaster. For many youngsters, a dime was hard to come by. Richard Happel Sr. stated, "Yes, I rode the roller coaster some. I didn't have much money to tell the truth about it. Harry Ditch and Sam Wastler used to run it. It was nice to get up in there and come around the tree tops, but the old wooden rig—the one big dip—I was always glad when that was over." Henry McKelvey termed the roller coaster "a scary ride. I was half afraid. I never rode it too much. If the wind was blowing, it would rock when it was at the top!" (Courtesy Judy Schlotterbeck.)

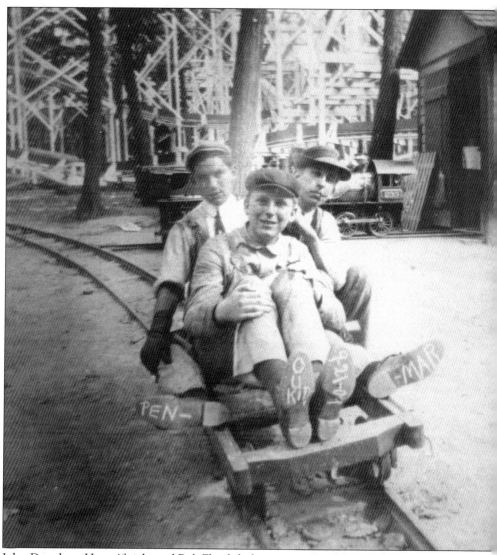

John Donahue, Harry Fleigh, and Bob Fleigh help promote Pen Mar via their shoes as they rid the rails on the miniature train. In the background the roller coaster can be seen. Virgini Bruneske, who worked at the nearby photographic studio, related that on "many a hot nigh after we closed, Mr. Ditch would say, 'Come over and cool off [on the roller coaster] Occasionally, we'd go over and get the last ride." (Courtesy Judy Schlotterbeck.)

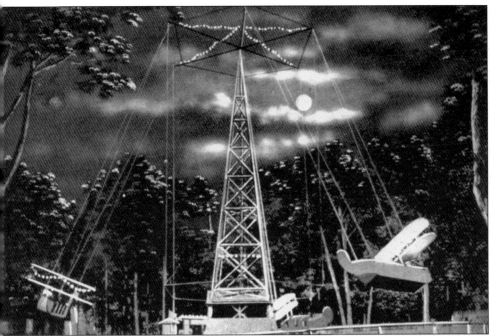

ne of the later attractions at Pen Mar Park appeared in the 1920s. Located near the Western
aryland Railway siding that came into the park, the seaplanes gave riders the feeling that the
anes were taking off high above the valley below. Kay Whetstone remembers "the seaplanes
at swung out. That was a little scary, too. They were on the edge of the hill up there, and
hen they would swing out, they really went out over the gully. I can remember my father
companied me on that. He wore this stiff-rimmed straw hat. At one point it swung out, and
s hat got nicked by one of the wires, so I never got to go on that one again." The seaplanes
ere later moved to Row's Amusement Park along the Conococheague Creek west of
agerstown. (Courtesy Virginia Ludwig and Judy Schlotterbeck.)

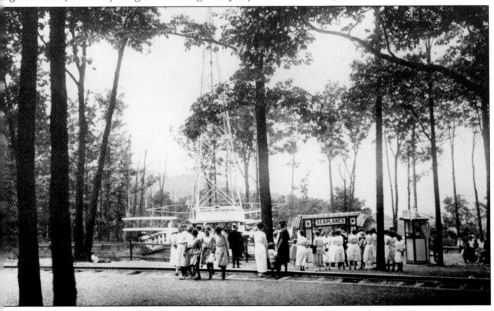

For Linford Hartle, "the great feature" was the picnic lunch that his mother had prepared. "My mother would make potato chips, fried chicken, and cakes. She usually made two cakes—chocolate cake and a white one. She always had a large container of lemonade. They had picnic tables galore." Nancy Gehr remembers taking the WM train to Pen Mar with members of the Hagerstown Church of the Brethren for their annual picnic to the Blue Ridge Mountains along with First Christian Church, First Brethren Church, and the Washington Square Methodist Episcopal Church, all from Hagerstown. Elizabeth Sprecher Arnett, who grew up on a farm, also recalls going to Pen Mar with the Hagerstown Church of the Brethren. "We very seldom ever went anywhere because you had the cattle to take care of." The Presbyterians' picnic in 1900 attracted nearly 15,000 people. (Courtesy of the Western Maryland Room of the Washington County Free Library.)

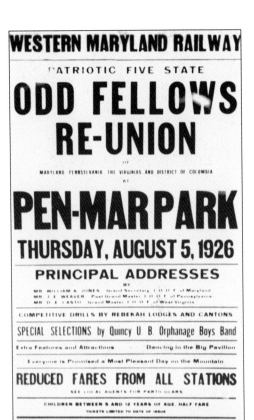

When the Odd Fellows Reunion was initially held at Pen Mar Park in 1910, the Western Maryland Railroad designated a special area that the group could hold drills and demonstrations. At the Odd Fellows Reunion 1913, the Wayne Band under the direction of Prof. Harry Krepps and the John Bohl Orchestra entertained guests throughout the entire day. Below, members of the organization line up for a drill. According to former park employee Lindy Bumbaugh, the wooden water tank in the background always seemed to be running over." The 16-foot high tank held 20,000 gallons of fresh spring water. (Courtesy *Maryland Cracker Barrel* and Judy Schlotterbeck.)

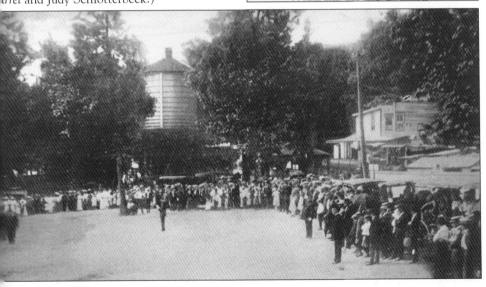

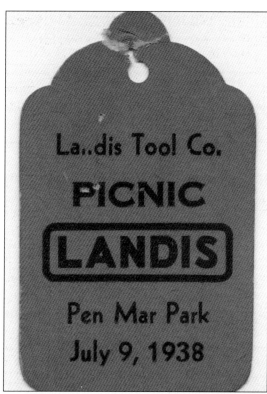

The Landis Tool Company in Waynesboro was one of the numerous factories in the area that annually treated their employees and families to a day in the park at Pen Mar. (Courtes Virginia Bruneske.)

The photo below shows a Pangborn Corporation (Hagerstown) picnic at Pen Mar Park in 1939. The company opened its first plant in New York City in 1904 before moving to Hagerstown in 1912. Company officials chartered trains to take hundreds of workers and their families to the annual picnic, which climaxed with drawings for as many as 100 door prizes. The company grew to international prominence as the largest blast cleaning and dust control industry in the world. (Courtesy Washington County Buildings, Grounds, and Parks Department.)

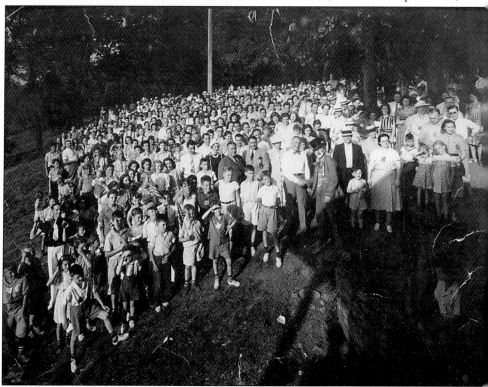

TABLISHED 1890.
CORPORATED 1897.

A. H. STRICKLER, PREST.
DANIEL HOOVER, VICE-PREST.
J. E FRANTZ, SEC AND TREAS.
A. B. LANDIS, SUPT.

LANDIS ৯৯ ৯৯
TOOL COMPANY

uccessors to LANDIS BROS. Waynesboro, Pa.

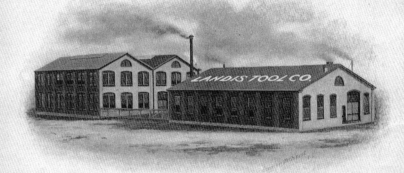

⚜⚜⚜MANUFACTURERS OF⚜⚜⚜

Universal and Plain
Grinding Machines

FOR FINISHING CYLINDRICAL, CONICAL and PLANE FACE SURFACES

⚜⚜⚜⚜⚜⚜⚜⚜⚜

AN INDISPENSABLE IN EVERY
MACHINE SHOP

———

CATALOGUE MAILED ON APPLICATION

1897, brothers Abraham B. and Frank F. Landis opened Landis Tool Company, a
anufacturer of threading machines and die heads. Landis Tool was one of the companies that
ok advantage of nearby Pen Mar Park to host its annual picnic. Kay Whetstone fondly
membered the "big shop picnics. They'd give you strips of tickets. That was wonderful for us
ds. We could ride everything!" (Courtesy Mrs. Zel Smith.)

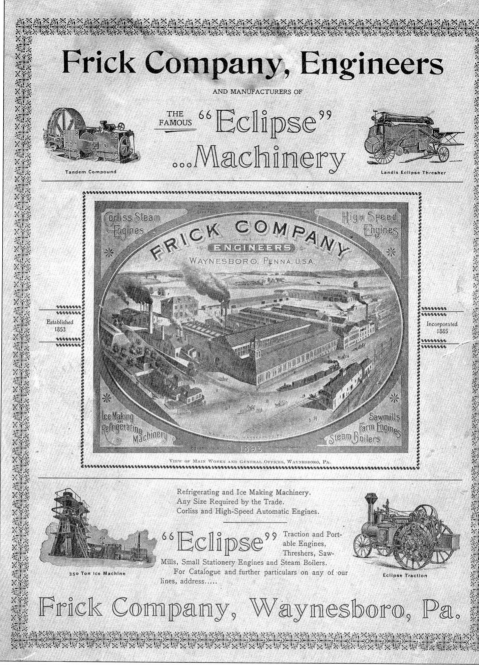
The Frick Company in Waynesboro also annually treated their employees and families to a d[...] in the park at Pen Mar. In 1848, George Frick opened a plant in nearby Quincy for t[...] manufacture of grain drills and small machinery. He later moved the plant to Ringgold bef[...] finally settling on Waynesboro in 1861. The Frick Company was originally noted for t[...] manufacture of steam engines. In 1881, Frick's son Abraham led the company in a ne[...] direction: the manufacture of ice and refrigeration machinery. (Courtesy Mrs. Zel Smith.)

THIS SPACE FOR WRITING MESSAGES

123499

POST CARD

Everybody's Day
.....AT.....
Pen - Mar Park

PAUL WISSEL
4314 Rokeby Rd.
Baltimore 29, Md.

THIS SPACE FOR ADDRESS ONLY

Thursday, August 29th

PRIZE WALTZ - - - Afternoon and Night

BABY SHOW - - 1:30 P. M.

DOUGHNUT EATING CONTEST - - 5:00 P. M.

EVERYBODY'S COMING » » ARE YOU?

postcard (above) announcing Everybody's Day at Pen Mar Park reveals the name of Paul Wissel, a summer resident of the Pen Mar area. Everybody's Day, traditionally the third Thursday in August, was usually the busiest day of the season at the park and drew as many as 10,000 visitors. A variety of activities for the special day was advertised in newspapers along the eastern Seaboard. Games, pie-eating contests, watermelon-eating contests, pig-catching contests, and races were held, in addition to numerous contests involving babies (below). In 1913, Everybody's Day also featured "grotesque kite flying by Chinese experts and a beautiful display of fireworks in the evening." As always, music played a prominent role in the day's activities. (Courtesy Virginia Bruneske and Virginia Ludwig.)

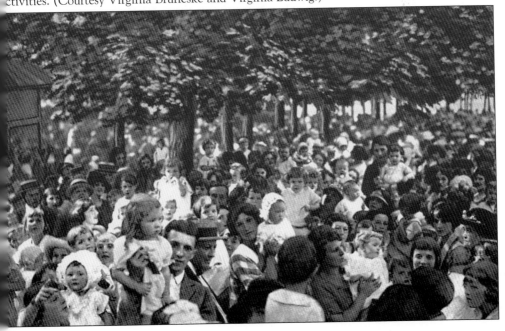

In 1920, Ralph Neikirk was judged the "fattest baby" on Everybody's Day at Pen Mar Park. Ralph was 9 months old and weighed 29 pounds. In 1921, more than 500 children were registered for the various baby contests. (Courtesy *Maryland Cracker Barrel.*)

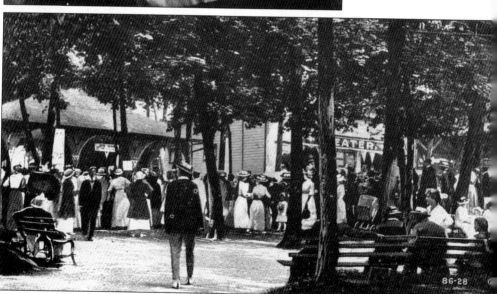

Adults gather for the Baby Show on Everybody's Day. Contests featuring the infants included the prettiest baby girl, handsomest baby boy, largest baby, smallest baby, boy with the most freckles, the handsomest twins, and the baby with the prettiest curls—not necessarily a little girl. Exhibition dances were another attraction on Everybody's Day. For years Tom Tobin, a dance instructor at the park from Baltimore, offered free lessons to youngsters who later performed exhibition dances. (Courtesy *Maryland Cracker Barrel.*)

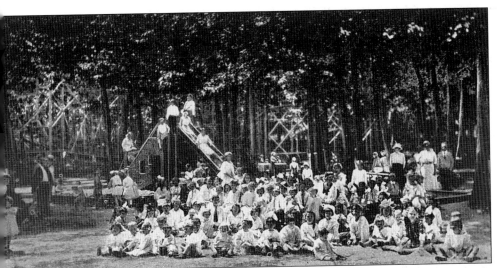

The sand pile and slide were two of the most inviting attractions for children at Pen Mar Park. Hagerstown's Trinity Lutheran Church always planned their annual picnic at the park a year in advance. Before the Western Maryland train arrived at Pen Mar, pastor Dr. J. Simon and Hagerstown storekeeper Harry S. Myers handed out passes for the various rides. Lindy Bumbaugh remembers that "there were three different colored tickets: the green one offered six rides for 25¢; the white ones, a nickel a ride; and the red tickets were for Sunday School and company picnics." (Courtesy Janet Dayhoff and the Western Maryland Room of the Washington County Free Library.)

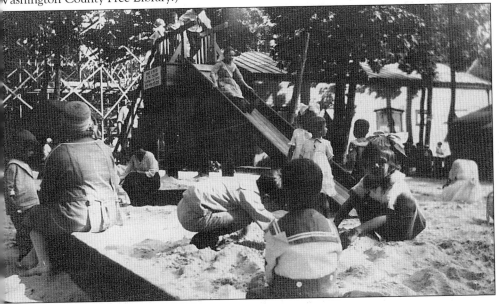

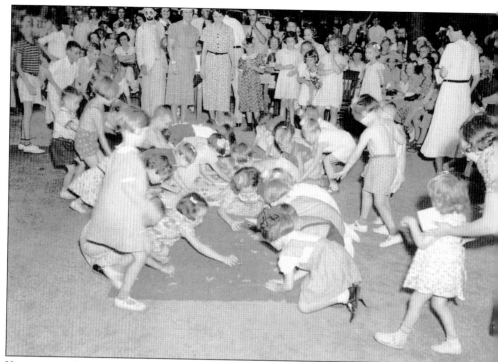

Youngsters take part in a candy scramble at the park. Harry S. Myers often provided prizes for game winners and peanuts for the famous children's peanut scramble. A day at the park also included relays, three-legged and sack races for the children, horseshoe tosses and softball games for the men, and guessing games and the rolling-pin toss for the women. (Courtesy Western Maryland Room of the Washington County Free Library.)

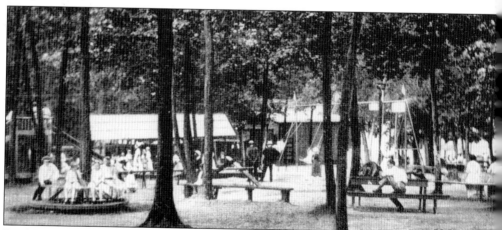

Pen Mar Park's playground provided plenty of seesaws, swings, swinging rings, and a horizontal bar for active youngsters. For Kay Whetstone "the sandbox and the sliding board were the big attractions; of course, they didn't cost anything. When I got a little bit older, I wanted to go on things that cost money, and I can remember us kids had to choose. You weren't going to be able to get on everything." (Courtesy Judy Schlotterbeck.)

76

group of well-dressed young people poses for a picture at Pen Mar. On Everybody's Day in 1911, the best-dressed gentleman at the park in the afternoon received a silk umbrella, while the best-dressed lady got a 35-piece Dresden china set. In the evening, the best-dressed gentleman got an ebony and silver brush set and his counterpart was awarded a seven-piece fine china fish set. (Courtesy Mrs. Zel Smith.)

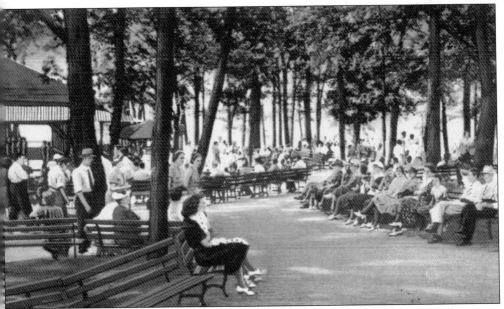

Enjoying a day in the park is Mrs. F.W. Heefner, seventh from the right. To her left is her sister, Mrs. Jack Hanback, and to her left is their mother, Mrs. A. Clyde Morgan. At left in the photo is the dance pavilion. (Courtesy Virginia Ludwig.)

Roy Hull operated the candy stand near the carousel. Lindy Bumbaugh recalls that "he froze his candy bars—Three Musketeers and Power House—three in a pack for 5¢." Virginia Bruneske added that the entrepreneur was a teacher during the school year. (Courtesy Virginia Bruneske.)

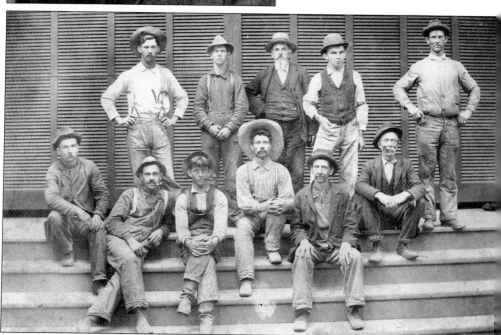

Above is Pen Mar's maintenance crew. Warren Kettoman is in the large hat in the center of the front row. In 1908, William Hahn was in charge of preparing the park by May 30 with the assistance of 16 workers. In 1914, the Western Maryland Railway spent $7,974.22 to operate the park and made a profit of only $900.64. (Courtesy Richard Happel Sr.)

PEN MAR PARK MD.

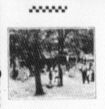

The Summer Playgrounds for Children and Grown-ups

HIGH ALTITUDE Always Cool and Breezy

DANCING - MUSIC - RIDES - HORSES - PONIES

For Ruth Durbin Shank, a day at the park was the highlight of the summer. "Oh, Pen Mar Park was something. I love it yet! We'd stand there and watch them dance—just roam around." The daughter of a farmer near Hagerstown, Mrs. Shank added, "That was a big thing for us to go, but we had to have all of our work done." (Courtesy *Maryland Cracker Barrel*.)

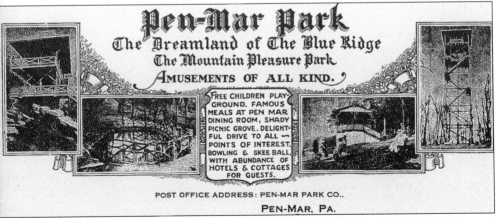

Pen Mar Park was truly a "Dreamland of The Blue Ridge" for Weldon "Peck" Eshelman and Rosemary Thompson, who later became Mr. and Mrs. Eshelman. Mrs. Eshelman recalls that part of the charm of Pen Mar was the elegant manner in which men and women adorned themselves. At 18, Eshelman had his first date. Driving his father's 1935 Plymouth, he took the young lady to Pen Mar, where he was totally embarrassed by his "buddies" to the point that he soon drove his "sweetheart" back down the mountain. (Courtesy Mrs. Zel Smith.)

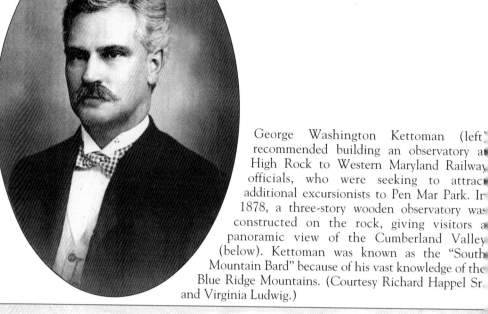

George Washington Kettoman (left) recommended building an observatory at High Rock to Western Maryland Railway officials, who were seeking to attract additional excursionists to Pen Mar Park. In 1878, a three-story wooden observatory was constructed on the rock, giving visitors a panoramic view of the Cumberland Valley (below). Kettoman was known as the "South Mountain Bard" because of his vast knowledge of the Blue Ridge Mountains. (Courtesy Richard Happel Sr. and Virginia Ludwig.)

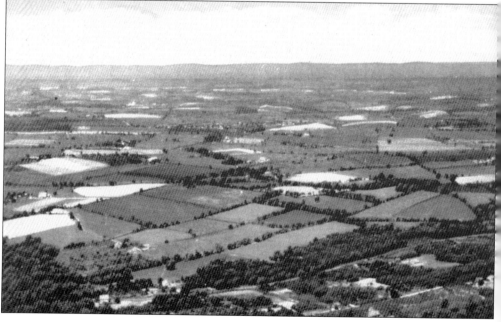

Hackmen, who transported visitors from Pen Mar Park to High Rock, Brinkwood, and Ragged Edge, were identified by numbered badges. Hackmen were required to secure a license from the Western Maryland Railway, which owned and maintained the 33-foot-wide road from the park to High Rock. (Courtesy Virginia Bruneske.)

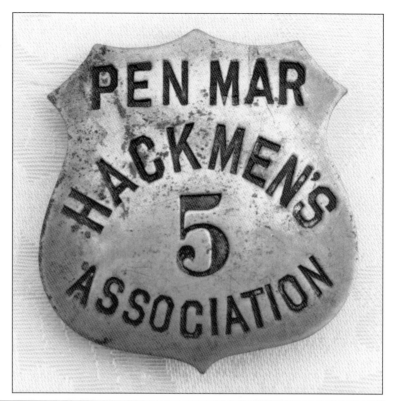

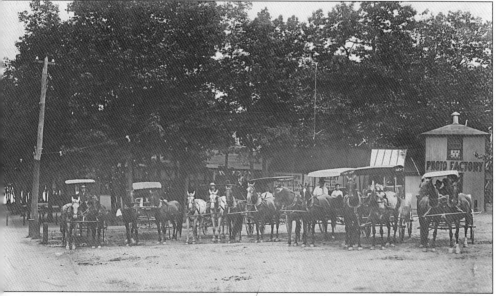

Hackmen were confined to an area outside the park near the photographic studio. In 1905, a fence enclosed the area used by the hacks, but a gate was intentionally omitted. A newspaper article in that year stated, "Only licensed cabs and hacks will be allowed inside the enclosure. These will be bound by the company's fixed rates, and if they violate them, their license will be revoked. The whole purpose of the fence is to break up the extortion by unlicensed hackers." (Courtesy David Cline.)

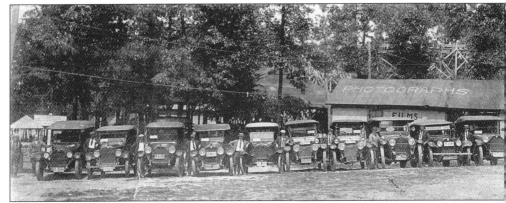

For many excursionists to Pen Mar, the first order of business was to venture up to High Rock. An early visitor observed, "Every sort of vehicle is brought into requisition and packed to its utmost capacity with passengers, until one fears that the springs or the wheels may give way beneath the ponderous load. And then away they go, amid the jests of the drivers and the din of their voices urging the overloaded teams up the mountain." Later, the horse-drawn hacks were replaced by the "horseless carriage." (Courtesy Henry McKelvey.)

In 1929, a group of men including Ed Ditch paid the Western Maryland Railway $300 for the rights to operate hacks to High Rock. In 1899, a trip from Pen Mar to High Rock and back cost 15¢. To continue further to Mt. Quirauk was an additional 15¢. For another dime, adults could go to the Blue Mountain House, while children could make the trip for a nickel. (Courtesy Judy Schlotterbeck.)

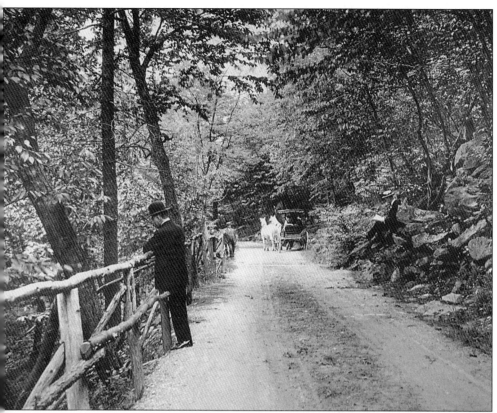

One account of the road (above) to High Rock read, ". . . a feat which was considered an engineering marvel hardly inferior to the Erie Canal." A newspaper article stated that the wooden observatory (below) was built "within three weeks . . . on a solid rock natural foundation." Upon its completion in 1878, the observatory was painted a subdued cream with red trim. The roof itself was of red composition material. For years the site was known as "The Place of Perpetual Breezes." (Courtesy Virginia Bruneske and Judy Schlotterbeck.)

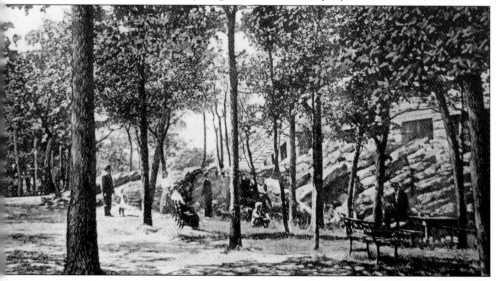

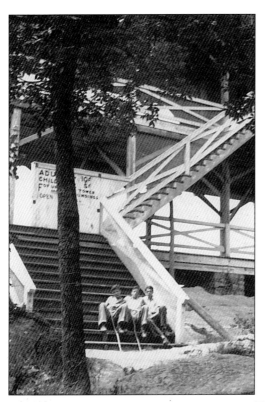

The Wissel brothers sit at the base of the High Rock observatory (left) at an elevation of 2,000 feet above sea level. During the summer of 1878, a watchman was fired for charging people a nickel to climb the tower and pocketing the money without authority. In 1883, historian J. Thomas Scharf recorded in his *History of Washington County*, "As far as the eye can reach, the valley is thickly studded with towns, villages, hamlets, and farmhouses, and the landscape consists of undulating plains, silvery streams, projecting mountain peaks." (Courtesy Virginia Bruneske, Wissel Collection, and Virginia Ludwig.)

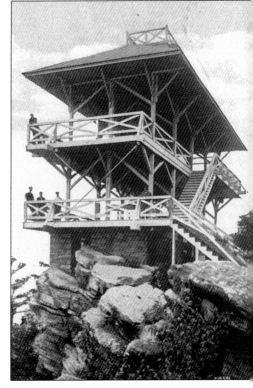

With binoculars, visitors to the High Rock observation tower might catch a glimpse of the town clock in Chambersburg, 24 miles away. An 1879 WM travel brochure noted: "The panorama of the Cumberland Valley is beyond doubt one of the grandest afforded in this country. Looking for miles in any direction, beautifully cultivated fields of grain, here and there a town or village meet the eye and stamp indelibly upon the mind a scene never to be forgotten." (Courtesy Kittochtinny Historical Society Library.)

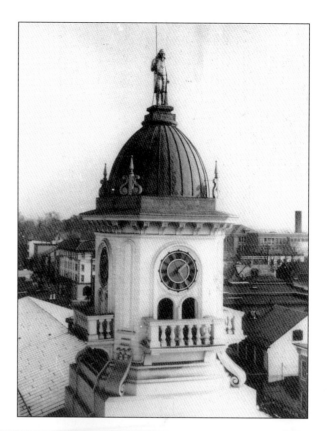

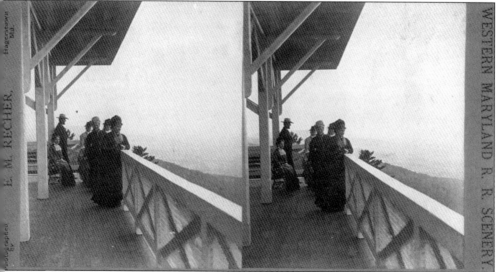

This stereoscopic view captures a group of sightseers on the wooden High Rock observatory. Richard Happel Sr. remembers the day when the most popular means of transportation to High Rock was the "hacks with the fringes around the top. People would get in there and go up to High Rock or maybe up to Mt. Quirauk." Lindy Bumbaugh remembers Clarence Smith pulling the tower down with a truck on Labor Day in 1939. (Courtesy Washington County Historical Society.)

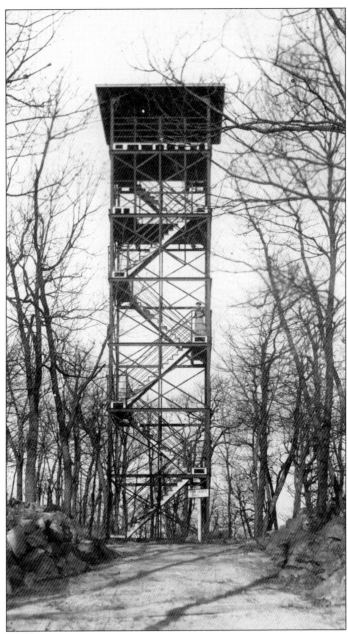

A road from High Rock led visitors to Mt. Misery, 2,400 feet above sea level. Around 1883, a 70-foot tower was built. Later, an 80-foot steel tower replaced the wooden structure. From here one could see 22 counties in the states of Maryland, Pennsylvania, Virginia, and West Virginia. Midway up the tower, a woman can be seen. A sign that appears at the base of the tower states "For Ladies Only." Richard Happel Sr. recalls that between High Rock and Mt. Quirauk "there were places (overlooks) called Ragged Edge and Brinkwood. I remember when I was old enough to have an old car, I'd drive in around Ragged Edge. There were still some rocks in the roadway but the old Model-T Ford took care of that, you know." On one occasion Happel spent the night atop the Mt. Quirauk tower with a friend, who was a fire warden. He said, "No sleeping for me" because of the movement of the tower in the wind. (Courtesy Virginia Bruneske.)

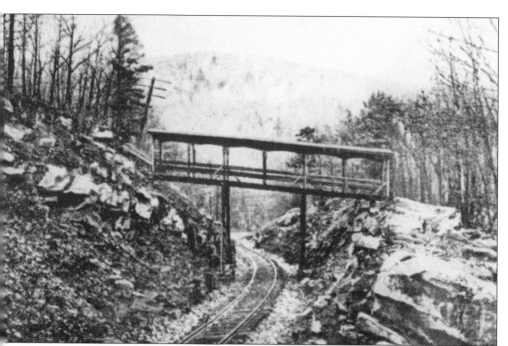

Pictured is the second of three bridges west of Pen Mar Park that led to Glen Afton. Young couples would walk five minutes to a small pavilion surrounding Glen Afton Spring. A travel brochure pointed out that Pen Mar had numerous locations like Glen Afton Spring, where young men could "pop the question without fear of disturbance. If her family is the kind that parks in the parlor every time you call, this is your opportunity." (Courtesy Judy Schlotterbeck.)

At Glen Afton Spring, the Western Maryland Railway erected a pump house to supply the park and the nearby Blue Mountain House with fresh spring water. The pumps also brought water to a wooden tank at the south end of the park. For more than 10 years, Warren Kettoman served as the pumpman at the spring. One of the familiar figures at Pen Mar Park was Otho Jones, a blind man who sold pencils. On Sundays when Kettoman's wife would bring him fried chicken for lunch, she always prepared enough for Otho, who died in 1942. (Courtesy Virginia Ludwig.)

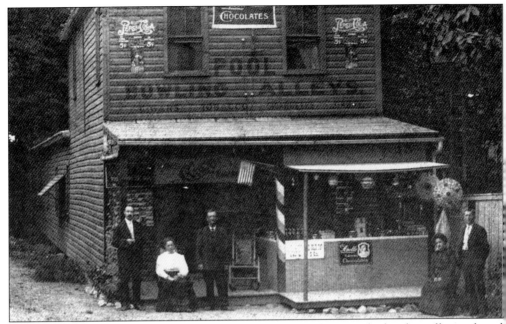

Shortly after 1900, Waynesboro resident Harry "Mike" Crilly opened a bowling alley and pool hall just outside the park. As a youngster, Nelson Hause set pins for his uncle Harry. On busy days Crilly solicited the help of his brothers, Guy "Mike" and Floyd "Mike" Crilly. Hause added that the pinboys amused themselves by razzing the bowlers who "could give it as well as take it." Mrs. Crilly's vegetable soup was well known to park visitors. (Courtesy *Maryland Cracker Barrel*.)

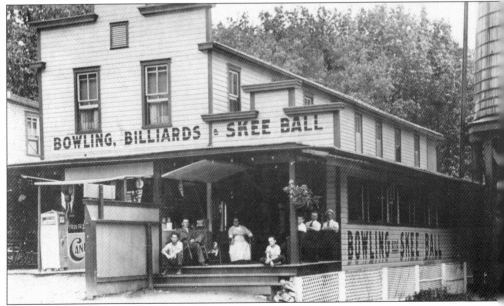

Crilly's bowling alley operated until the 1950s before being torn down in 1974. Waynesboro native Allen Smetzer worked at the bowling alley, which had five lanes. "We lived above the bowling alley all summer. We'd get a couple of hours off in the morning after we'd get our work ready and weren't busy. We'd just come down through the park and see our friends. We knew most of the people that worked in the park." (Courtesy Judy Schlotterbeck.)

One of the attractions just outside of Pen Mar Park was a skating rink, located on the site of the Crout Hotel. In the photo below, O.D. Sherley, who operated the rink, is seen standing between two trees in the foreground. Years later, a new skating rink opened at Pen Mar on the ground floor of the Mt. Forest Inn. According to a newspaper article in 1908, the Western Maryland Railway had plans to erect a rink along the path that led from the park to Glen Afton Spring and advertised the rink as one of the leading attractions at the park. (Courtesy *Maryland Cracker Barrel.*)

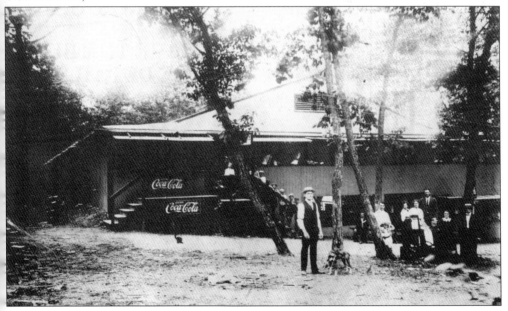

Pen Mar Park Remembered

Music and Lyrics by
Katherine Steck Whetstone
Kay Whetstone

When a new park was dedicated in 1977, Mrs. Kay Whetstone composed a song about her early memories of the old Pen Mar Park. She recalls: "We thought our mother's fried chicken was better [than the 50¢ chicken dinners at the Pen Mar Dining Room]. . . . We'd always have fried chicken, potato salad, deviled eggs, chocolate cake, and iced tea. . . . You could have left your pocketbook on the table. It just seemed like such a safe, nice place." The refrain from Mrs. Whetstone's song traces the journey to Pen Mar from Waynesboro:

Pen Mar in summertime! Beautiful, beautiful summertime.
Sun-filled days and fun-filled nights at Pen Mar!
Pack up a lunch, hurry down to the square,
The open trolley's waiting there.
Hop aboard and off we go to Pen Mar!
Wayne Heights hill, then Rouzerville!
Oops! Here comes a curve!
Children squeal and grown-ups reel,
Boy this beats the automobile!
Nickel a ride, and there's dancing too.
We swing and sway the whole night thru'.
Music stops, we bid adieu to Pen Mar.
(Courtesy Kay Whetstone.)

Three
STAYIN' AT PEN MAR

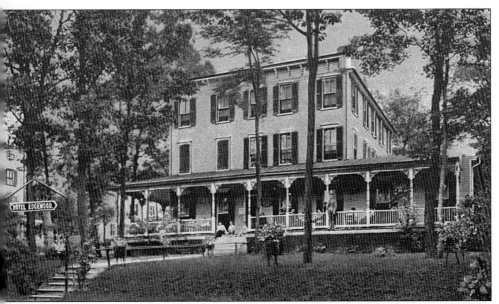

A visit of one day, one week, or the entire summer to Pen Mar became a tradition for many around the turn of the 20th century. With the pleasant breezes and the spectacular view, it is little wonder more than 100 hotels and boarding houses hosted a multitude of visitors. Two of the grandest hotels were the Blue Mountain House and the Buena Vista Spring Hotel, which accommodated nearly 1,000 guests combined. Pictured here is Hotel Edgewood, which was built in 1909. (Courtesy Mrs. Zel Smith.)

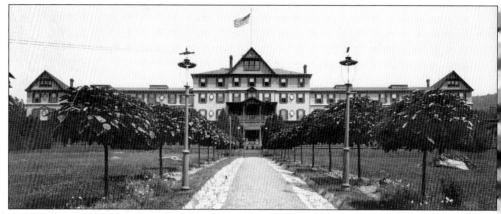

In 1883, the rambling yellow Blue Mountain House with its red trim was built a mile from Pen Mar Park in 76 working days for $225,000. A Baltimore columnist wrote, "A visit to the Blue Mountain House was as necessary, according to the old Baltimore viewpoint, as going to church on Sunday, or promenading Charles Street on Easter or being seen at the Monday German." (Courtesy Virginia Bruneske.)

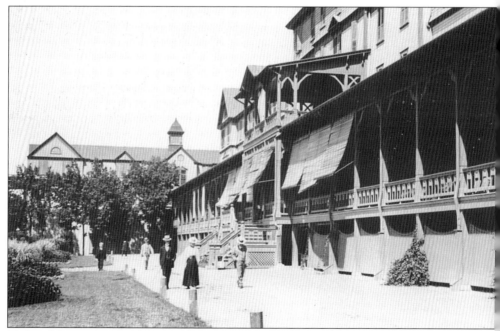

Made of Georgia pine, the Blue Mountain House was over 500 feet long. Its lavish rooms accommodated 500 guests, and it boasted a post office, elevators, room phones, steam heat, and its own power plant. "If you were a young millionaire or wished to make an impression on your best girl, you could take her to the Blue Mountain House, where dinner was a dollar (outrageous, but worth every cent of it) or to the Buena Vista Spring Hotel." (Courtesy WMRHS.)

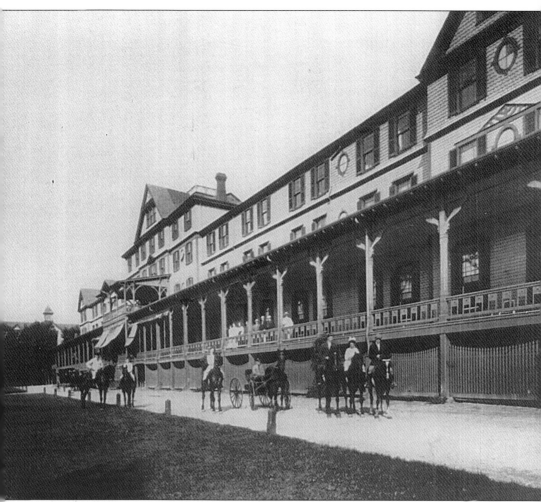

One of the amenities of the Blue Mountain House was horseback riding. The renowned Baltimore Riding Academy provided the horses and instructors for the hotel. Mounted at the far left in this 1913 picture is the riding instructor. Mounted next to him is John J. Gibbons Jr., and to his left is his sister Mary Gibbons, both the children of John J. Gibbons Sr., who managed the hotel from 1907 until it burned in 1913. Gibbons came to the Blue Mountain House in 1896 as an engineer when the hotel was experiencing trouble with its power plant. His stay was scheduled to last just four months but turned out to be 17 years. In 1907, Gibbons and Harry Bond leased the hotel from former Maryland governor Preston Lane and his father, William P. Lane. (Courtesy Dolores Sattler.)

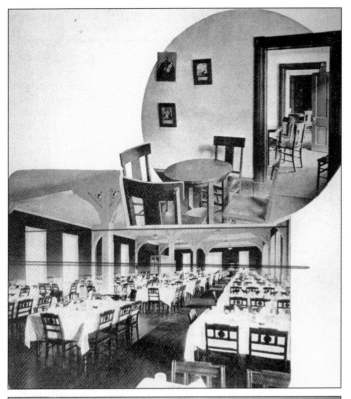

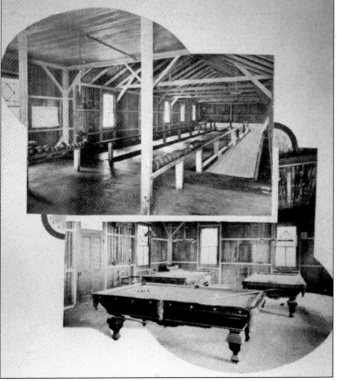

During its short history, the Blue Mountain House hosted many dignitaries, including Presidents Woodrow Wilson and Grover Cleveland. In addition to the natural beauty of the site, the hotel offered guests the use of social parlors and clubrooms, as well as a billiard parlor, bowling alleys, tennis courts, and a lawn for croquet. Several of the bandleaders at Pen Mar Park provided nightly dance music, and on Saturday nights a full dress ball was held. Gibbons recalled that for Colonel Hood, "the attraction of the Blue Ridge resorts was simply the 'exhilarating atmosphere, pure water, scenic attractions—most favorable conditions for good health and pleasure." (Courtesy Judy Schlotterbeck.)

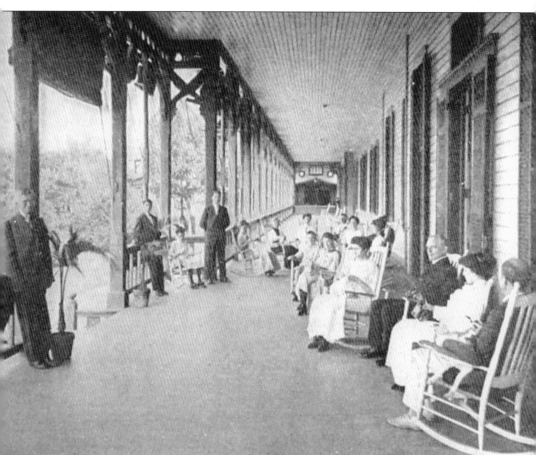

"Guests liked to sit in those big rocking chairs on the long, shady veranda of the hotel, greeting old friends and passing hours in conversation. Good food, pure water from mineral springs, and the pleasure of just sitting still for a while seemed to satisfy us so much in those days," reflected John Gibbons Sr. on his days as manager of the Blue Mountain House. "Most of the hotel guests came for a period of three months and brought their coachmen and footmen and other servants along." The splendor abruptly ended at 5:50 on the morning of August 5, 1913. Three hours later the hotel was a pile of rubble. As Gibbons related, "Only the chapel, the bowling alleys, and the stables escaped the flames. Fortunately, no lives were lost in the fire, but two persons were badly injured out of a total of 250 guests and staff. The Western Maryland immediately sent two 'rescue' trains to bring back to Baltimore more than 100 guests, many of whom, still in their night clothes, were taken to Pen Mar Park to await the trains and other means home." A newspaper article pointed out that "Frank Thomas, a colored porter, ran from room to room, calling the guests and quieting those who showed signs of panic, then gathered them together, he led them through a rear exit to safety." Thomas reportedly did not leave the building until he was assured that everyone was out. (Courtesy Judy Schlotterbeck.)

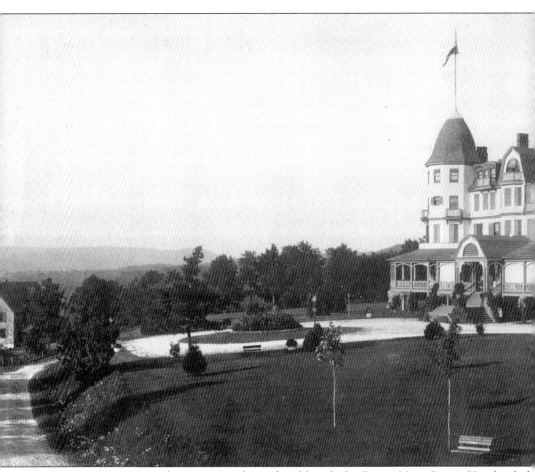

In 1890, construction began on another palatial hotel, the Buena Vista Spring Hotel, a half mile east of Pen Mar. The Renaissance style hotel, which opened on June 25, 1891, soon became the "summer capital" of the area and hosted dignitaries such as President Woodrow Wilson, Maryland governors William Preston Lane and Albert Ritchie, Adm. George Dewey and actress Joan Crawford. The hotel's first manager was Charles Webb, formerly with the Hamilton Hotel in Hagerstown. One of the hotel's unique features was an observatory atop the structure. Known as "The Seasons," the tower had four glass windows, each representing the colors of the seasons: vernal green, summer gold, russet and purple of autumn, and the fleecy form of winter. Guests could view the Cumberland Valley 2,000 feet below. With its 250 rooms, the hotel served 500 guests at rates of $2.50 to $3.50 per day or $12.50 to $20 per week. To transport building material up the steep incline, a standard-gauge light rail line was built from the Western Maryland's main line at Cascade. An advertisement for the Buena Vista Spring Hotel stated, "Where 'The Best In The World' Awaits you. A High-Class Summer and Fall Resort." (Courtesy Dolores Sattler.)

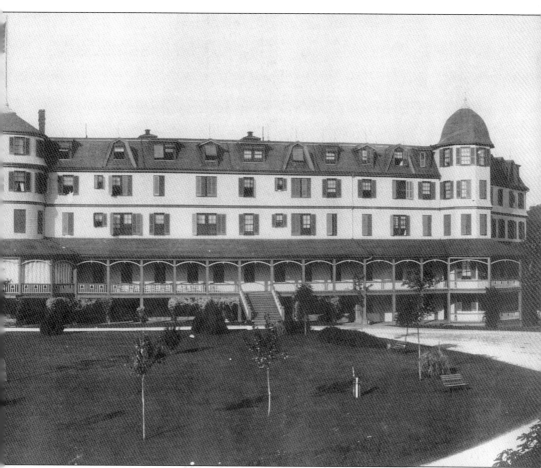

nn J. Gibbons Sr. managed the Buena Vista
ring Hotel from 1914 until 1931, when the
ndmark was sold to the Baltimore Society of
uits. Guests often told Gibbons that the view
m the tower "seemed to be the most beautiful
ht in all the world." Gibbons and his son also
sed and operated the Pen Mar Dining Room
d Pen Mar Hotel from 1915 to 1934. From 1929
1931, Gibbons and William Bowers leased Pen
ar Park from the Western Maryland Railway.
ourtesy Dolores Sattler.)

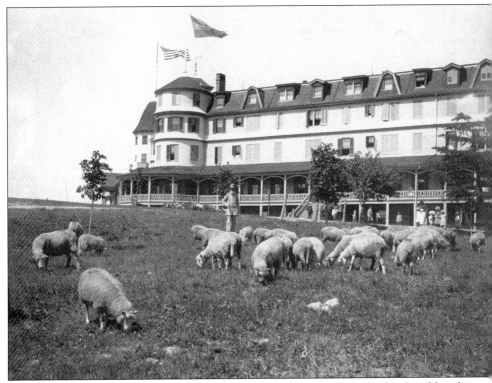

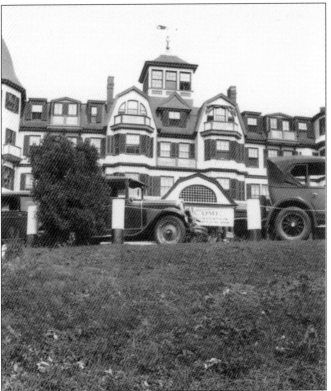

A shepherd and his sheep present a tranquil scene at the Buena Vista Spring Hotel. Initially, sheep were used to keep the hotel's go[.] course well manicured. Lat[er] hand mowers were used for trimming, with a three-ree[l] horse-drawn mower employed for the open area[s] on the course. (Courtesy Virginia Bruneske.)

John J. Gibbons Sr. remembered the days whe[n] there were no automobiles [at] the Buena Vista Spring Hotel. The day came, however, when all of that changed. "A hackman saw an automobile and its driv[er] soliciting his business. He had a gun and shot the tir[es] off the automobile machin[e]." (Courtesy Lindy Bumbaug[h].)

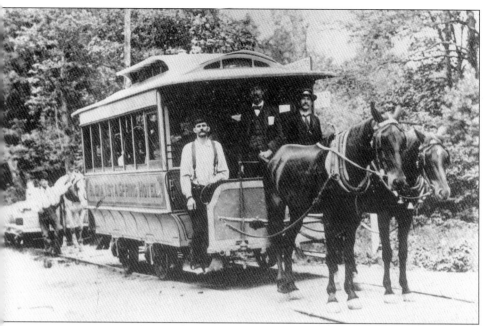

the infancy of the Buena Vista Spring Hotel, most of the guests arrived by train at the Buena
sta Station, a private depot on the Western Maryland line at Cascade. Guests were
nsported the two-and-a-half miles to the hotel in a horse-drawn trolley. Pulled by a pair of
rses, the trolley was followed by a single horse pulling the baggage car. The trip was scheduled
take 20 minutes, but the lead driver, Uncle Billy Hovis, usually made it in 12 minutes, always
ving precisely on time. (Courtesy WMRHS.)

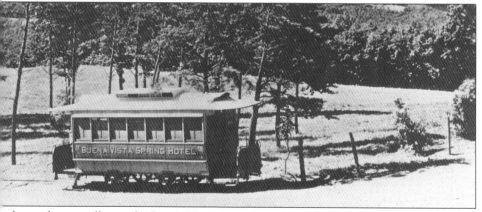

e horse-drawn trolley to the Buena Vista Spring Hotel was reportedly the last one in use in
United States. The rails were sold to the West Virginia Lumber Co. and torn up in the fall
1922. The trolley was lifted from its wheels and placed behind the hotel. Here children
shed it as a toy, but the rough treatment it endured soon prompted officials to "junk" the old
, which reportedly came from the nation's capital. (Courtesy WMRHS.)

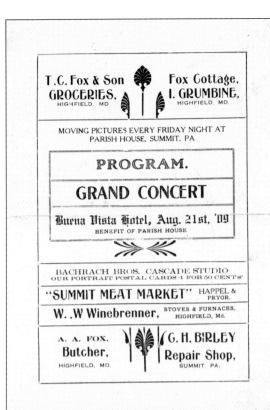

A grand concert at the Buena Vista Spring Hotel in 1909 is listed on a program cover at left in the midst of local advertisements. The hotel's concert hall and ballroom were located in a separate building. Hotel guests (below) enjoy the 15-foot-wide porch that ran the entire length of the structure. Some sources say the porch was 372 feet long, while other place the length at 492 feet. The signature hotel of the Blue Ridge was designed with three wings: one to the northwest, one to the southwest, and one to the south. (Courtesy Richard Happel Sr. and Judy Schlotterbeck.)

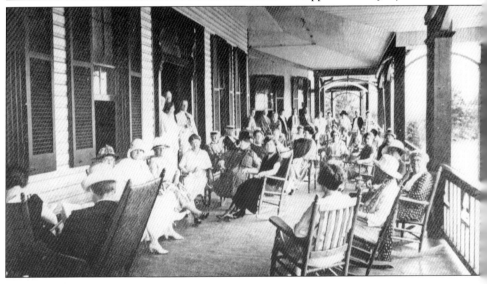

car barn provided shelter for cars at the Buena Vista Spring Hotel. What began as a six-car age soon turned into housing for more than 40 vehicles. The growing popularity of the tomobile and the Great Depression forced the hotel to close its doors in 1931. The Baltimore ciety of Jesuits purchased the facility for use as a retreat. The name was changed to llarmine Hall, after Robert Bellarmine, a 16th-century priest. Early on the morning of cember 8, 1967, arsonists torched the structure; all that remained were the massive brick imneys. (Courtesy Judy Schlotterbeck.)

e Robert E. Rennert Memorial Chapel was built in honor of Robert Rennert, who died in)8. Dedicated on July 18, 1900, the chapel still stands about 500 feet southeast of the former e of the Buena Vista Spring Hotel. Rennert was a partner in the Buena Vista Spring provement Co., formed in 1891, with Baltimore grocer George K. McGaw and financier lliam S. Rayner. The facilities, owned by the Jesuits, are used year-round. (Courtesy ginia Bruneske.)

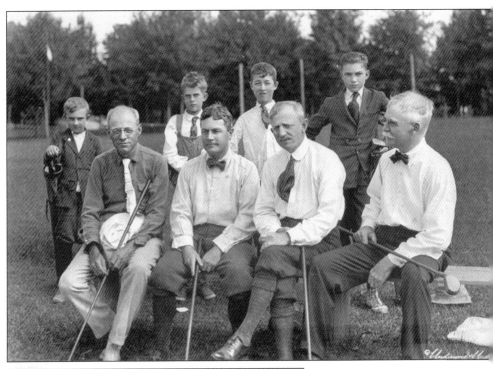

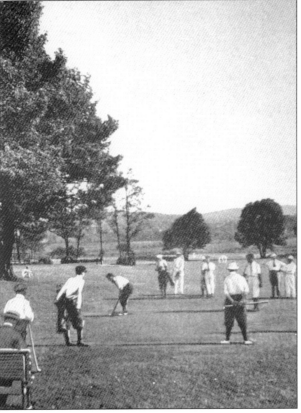

The Buena Vista Spring Hotel had a nine-hole golf course next to the Robert E. Rennert Memorial Chapel. In the 1920 photo above are, from left to rig (front row) Dr. Dabney from California, Judge Bryon from Baltimore, Judge Soper from Baltimore, and Frederick S. Valentine from Richmond, Virginia; (back row) caddies Tu Smith, Rich Smith, and Jap Eberly, and caddy master Bruce Hovis. Born in 1916, Earl Blair recalls, "I rode my bike (from Waynesboro). It would take me an hour to ride up to Buena Vis It was about 7 or 8 miles up the and going uphill all the time. I didn't mind the downhill ride, b I did mind going up. I just caddied for some of the fellows because the pay was good. Mr. Gibbons [Sr.] had invited me or behalf of my granddad [William H. Blair]." (Courtesy Collection of John E.N. Blair ar Judy Schlotterbeck.)

Buena Vista Spring Golf Course

BUENA VISTA SPRING HOTEL
FRANKLIN COUNTY, PA.

HOLE	DISTANCE	FIRST 9			PAR	BOGEY	SECOND 9.		
		SELF	OPPONENT				SELF	OPPONENT	
1	138	4	4	4	3	3	2	5	
2	268	4	6	4	4	4	5	7	
3	295	6	7	5	4	5	5	6	
4	266	4	4	5	4	4	4	4	
5	220	5	4	6	4	4	5	5	
6	160	4	3	3	3	4	4	6	
7	166	3	4	6	3	4	5	5	
8	122	5	2	3	3	3	3	5	
9	245	4	5	6	4	4	5	3	
	1880	39	36	42	32	35	38	46	

SELF

OPPT.

Signed

Signed
1930

THIS CARD IS SIX INCHES LONG.

...ctured is a 1930 scorecard from the golf ...urse at the Buena Vista Spring Hotel. ...riginally a six-hole course, it was later ...panded to a nine-hole facility. The card ...rrectly points out that the hotel was in ...nnsylvania, just north of the Mason-Dixon ...ne. Other activities offered to guests were ...nnis, bowling, motoring, horseback riding, ...ountain climbing, and swimming in a heated ...ol. (Courtesy Collection of John E.N. Blair.)

LOCAL GROUND RULES

Out of Bounds:
 No. 2—In woods to Right.
 No. 5—In woods to Right, South of old road.
 No. 6—In woods to Right, South of Buena Vista Ave.,
 also East of line from near telegraph pole and run-
 ning along West side of Monterey Ave.
 No. 7—In woods to Right, East of Monterey Ave.
 No. 9—West of Ice Pond on line of inside row of trees
 North of Buena Vista Ave.
All out of bounds—Another ball must be played from
 where first was struck and one stroke counted.

 No. 1—Lift out of driveways to Right,—not nearer green
 —without penalty.
 If in trap move club length from water pipe,—not nearer
 green and not out of trap—without penalty.
 No. 7—Lift out of water pipe hole rear of green,—not
 nearer green—without penalty.
 Ball over bank in road rear of green may be moved not
 over 2 club lengths—not nearer green or out of road—
 without penalty.
 No. 9—Ball obstructed by tennis court screen may be
 moved and dropped not nearer green—without penalty.

ETIQUETTE OF GOLF

1. A single player has no standing and must give way to
 all properly constructed matches.
2. No player or onlooker should talk or move during a
 stroke.
3. Displaced Turf must be replaced.
4. Do not play off the putting greens.
5. No player should play from a tee until the parties in
 front have played their second strokes and are out of
 range, nor play up to the putting greens until the
 parties in front have holed out.

Virginia Bruneske is pictured at the Point View, a small hotel near Pen Mar Park. In 1949, years after this photo was taken, Virgini[a] and her husband Bernard Bruneske purchased the Point View from Leon Werderbaugh. In Pen Mar alone there were 22 cottages or hote[ls] capable of hosting 834 visitors to the Blue Ridge Mountains. The Point View had seven bedrooms. (Courtesy Virginia Bruneske.)

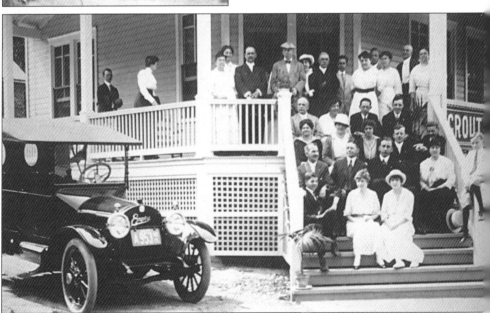

The Crout family and their guests are gathered at the Crout Hotel, which sat behind the Po[int] View. Harry Fleigh's first car is parked next to the hotel, a large yellow frame structure b[uilt] by Jason Crout in 1916. One of the last hotels in Pen Mar was the Pen Rock Hotel, whi[ch] burned on March 12, 1972. For years the 50-room hotel was owned and operated by Randol[ph] Debrick. The Pen Rock Hotel was a first-class hotel with an in-ground swimming po[ol]. (Courtesy Judy Schlotterbeck.)

he Mt. Vernon accommodated 75
guests. In 1934–1935, the family of
Arthur and Evelyn Frazer used the
entire hotel as its private residence.
Their son Paul remembers, "The
sound of the roller coaster, the
sound of the music from the merry-
go-round, you could hear
throughout the park—the sound of
the little train and its whistle, . . .
and the smell of barbeque that you
could smell throughout the park.
All of this was pure excitement for
a person of my age at the time!"
(Courtesy Judy Schlotterbeck.)

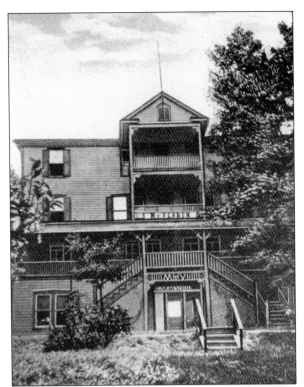

Built by George Washington Kettoman in 1897, the Hotel Maryland eventually expanded to
accommodate 100 visitors. The three-story hotel boasted a 130-foot façade with "long, cool,
breezy porches looking to the North." A 1906 prospectus noted, "Hotel Maryland IS NOT A
'CHEAP JOHN' HOUSE BUT OUR RATES ARE VERY REASONABLE." Rates were "one
in a room, 7 to 10 dollars Per week. Two in a room 6 to 8 dollars Per week." (Courtesy Richard
Happel Sr.)

Hagerstown residents Harry C. and Susan Duckett Grove summered at their Pen Mar cottage, the Woodly. The WM advertised: "There is not in all America a more beautiful, healthful and generally delightful location for summer cottages . . . there are already hundreds of beautiful cottages, and . . . ere long [there will] be thousands. In the territory between Blue Ridge Summit and Edgemont, an area of some six miles, there is a literal city of cottages, ranging from the humble bungalow of the middleman to the stately mansion of the millionaire." (Courtesy Ann Price Garrott.)

Grand View Heights was located just north of Pen Mar Park in Pennsylvania. The Waldheim (right) was one of the boarding houses. Built in 1909, the Waldheim was initially operated by the Kurtz sisters. An advertisement for the resort stated that there were "Full Course Breakfasts and Dinners. Sunday Dinners Upon Reservation." (Courtesy Judy Schlotterbeck.)

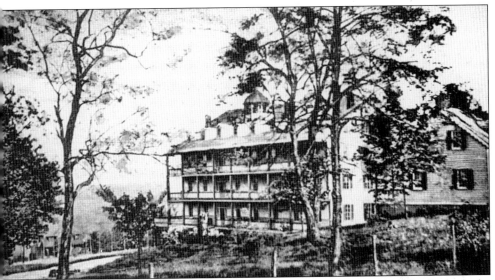

The Claremont was located at Charmian near Blue Ridge Summit. David Miller Sr. built the hotel in 1867. It contained 70 rooms accommodating 150 guests. Richard Happel Sr., who worked for the AL&J Happel Market at Blue Ridge Summit, recalls when Mrs. Charles Cowman was the proprietor. "I know the Claremont wanted several dozen chickens every week, and I helped to clean and get them ready. I got pretty good at dressing chickens. Mrs. Cowman's chickens were always large size." (Courtesy Judy Schlotterbeck.)

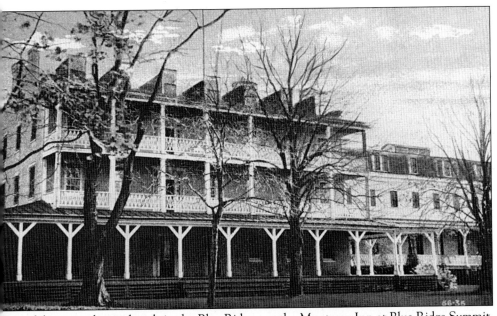

One of the most elegant hotels in the Blue Ridge was the Monterey Inn at Blue Ridge Summit. The hotel was the birthplace of Bessie Wallis Warfield, who later became the Duchess of Windsor. Many diplomats and politicians from Washington, D.C., made the summit their summer home and gave the area an aristocratic aura. (Courtesy Judy Schlotterbeck.)

On South Main Street in Smithsburg (above) were Hotel Sigler (left) and Hote Wishard (right). The two hotels could accommodate 30 and 12 guests respectively. Below the Cavetown Hotel, also known as the Smith Hotel, which was operated by Mr. an Mrs. Benjamin F. Smith, the grandparents of Charlie Slick, president of the Smithsbur Historical Society. In 1913, the community of Smithsburg had four other boarding houses Missouri Cottage, Cherry Hill, the Solitudes, and one operated by Mrs. J. Spielman. Th Willows and the Central in Cavetown also offered lodging and meals. (Courtesy Smithsbur Historical Society.)

Four

VISITIN' PEN MAR'S NEIGHBORS

One of the most prominent of Pen Mar's neighbors was Camp Ritchie. In 1926, the Maryland National Guard built the training site in nearby Germantown (now Cascade). The "Castle" was originally a reception center and later the headquarters for the 58th Infantry Brigade of the Maryland National Guard. The facility was named in honor of Albert C. Ritchie, governor of Maryland from 1920 to 1934. (Courtesy Pen Mar Development Corporation.)

Frederick native Robert F. Barrick was chosen by Maj. Ger Milton A. Reckord to design and build the National Guard facility. On May 31, 1926, Barrick wrote, "Well, here we stood. Challenge: Go ahead, make a camp out of this place." A later journal entry said, "Tota cleared area would hardly be 60 acres. There was stone everywhere; wherever one looked there were stone fences around small cleared fields abou five feet wide and four feet high." (Courtesy *Maryland Cracker Barrel*.)

The 1st Regimental Band of the Maryland National Guard in 1928 is standing in front of the "Castle." Randolph Brandenburg is the bugler in the second row, eighth from the left. George E. DeLawter, company clerk and truck dispatcher for Co. D. 104th Quartermaster Regiment recalled, "Never will I forget the Sunday afternoon parades or those of the annual Governor's

The "Castle" was possibly Lieutenant Colonel Barrick's defining achievement. Reportedly, Barrick employed the castellated style popular at National Guard armories in the country between 1877 and the early 1900s. Highfield resident Marshall Bowman, who was "recruited" by Barrick to work at Camp Ritchie, remembers Barrick as "a most unusual man; there was nothing he couldn't do. I think he had a vision of the fort long before it was built! He had it all in his mind!" (Courtesy Virginia Bruneske.)

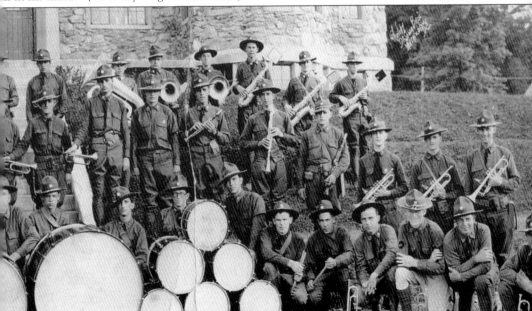

Day events. Parades were made possible by the immaculately groomed officers and men of the 'Dandy' 5th of Maryland, 5th Regiment of Baltimore, and the 1st Regiment of the Maryland counties. Thousands of our countrymen came from far and wide to view this spectacle for spectacle it was in every detail." (Courtesy Randolph Brandenburg.)

Maryland National Guardsman Randolph Brandenburg is seen near the tent "barracks" at Camp Ritchie in 1928. Located along what is now Barrick Avenue, the tents were situated behind the original 19 kitchens, 3 mess halls, and 3 enlisted men's baths built in 1926. This area of the base was referred to as "A" area. In 1951, Camp Ritchie became known as Fort Ritchie, after the U.S. Army purchased the site from the State of Maryland for $2,350,000. (Courtesy Janet Marshall.)

In 1927, the 200-yard target pit and firing line, the machine gun range, and the target house were constructed. Marshall Bowman is pictured "spotting" at the firing range. In the foreground is Cascade resident Frank Moore, who at the age of 14 ventured to the military base. "I'd sign up with Captain Barrick to put up targets for the Eastern Smallbore Rifle Association." Around 1926, Moore's father Jacob helped form the Mt. Quirauk Rod and Gun Club, which used Camp Ritchie's rifle ranges. (Courtesy Marshall Bowman.)

A 1928 news release stated: "The Enlisted Men's Club (Lakeside Hall) with its wide, deep rear porches looks out over Lake Royer. A bathing pier runs 150 feet out into the lake. . . . Canoes and boats lie along the shore. The porches of the clubhouse face one of the main roads and the parade grounds." On October 1, 1998, Fort Ritchie closed, sending shockwaves throughout the Blue Ridge area. (Courtesy Pen Mar Development Corporation.)

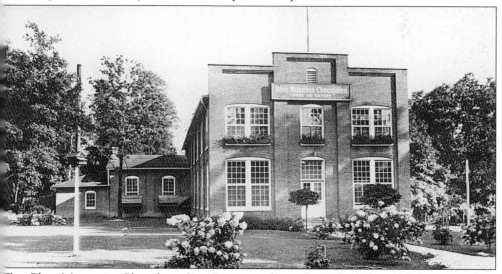

The Blue Mountain Chocolate Co., Inc., was located at Cascade near Camp Ritchie. Richard Happel Sr. related that a candy maker by the name of Jansen lived near what later became known as Chocolate Park. Happel noted that when brothers Walter and Harris Summers moved into the area, "They got him to set them up—to provide them with what they needed to know to get into the candy business. So they built the chocolate company." (Courtesy WMRHS.)

IN THE MIDST of THINGS

Located near Pen Mar, Waynesboro was promoted as being the "touring center of the celebrated Blue Ridge region, embracing Southern Pennsylvania and Northern Maryland and Virginia. At the pivotal center of unsurpassed scenery and historical association, Waynesboro truly is 'In the Midst of Things.' The community is located on the Buchanan Trail, a spur of the Lincoln Highway 12 miles to the north. The nation's oldest highway, the National Pike, lies 12 miles south of Waynesboro." (Courtesy Mrs. Zel Smith.)

114

On June 22, 1922, the former Melview House opened as Camp Louise, a camp for Jewish girls. Thanks to the generosity of Aaron and Lillie Straus, the camp welcomes several thousand girls each summer. Ida Sharogrodsky, a social worker for the Hebrew Immigrant Aid Society, conceived the idea of converting the old hotel into a summer camp. Officials at Camp Ritchie in the 1930s extended to campers the privilege of using Lake Royer, where Camp Louise later built its own swimming facilities. (Courtesy Virginia Bruneske.)

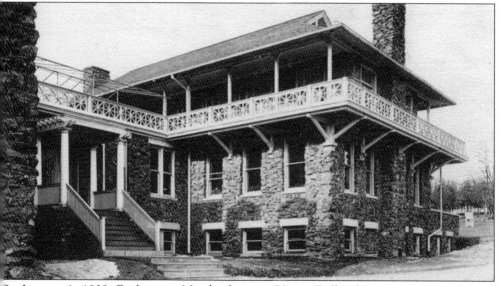

On January 1, 1909, Funkstown, Maryland native Victor Cullen became superintendent of what came to be known as the Victor Cullen State Hospital for tuberculosis patients in Sabillasville. All 200 beds were filled, prompting Dr. Cullen to expand the facilities. In 1912, the John Walter Smith Reception Hospital opened with 208 additional beds. In 1911, Dr. Cullen had a train station built on the grounds and was named stationmaster and surgeon for the Western Maryland. Dr. Cullen also opened a training school for nurses. (Courtesy Janet Dayhoff.)

One of the stores serving the hotels and boarding houses in the Pen Mar region was the Summit Meat Market, which was operated by Mr. Pryor and William Happel, the father of Richard Happel Sr. Happel later became a meat cutter at Blue Ridge Summit for the AL&J Happel Market, owned by William Happel's brothers John and Albert. Richard Happel Sr. remembers the truck that delivered ice to the market daily. As the truck "creeped up Rouzerville Hill, water ran out the back end. You knew it was Fitz's ice truck." Below is the Blue Ridge Summit Department Store and Post Office. There were 16 hotels and boarding houses at Blue Ridge Summit in 1913 to accommodate excursionists traveling the 69 miles from Baltimore. (Courtesy Richard Happel Sr.)

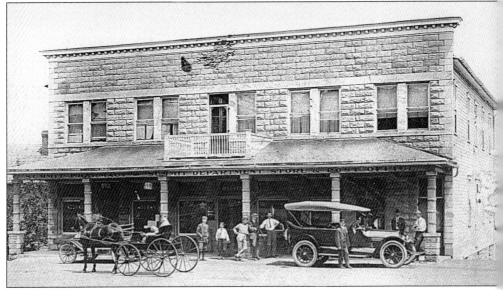

Visitors referred to the falls as the Cascades, while locals called it Falls Creek. The water cascading over the rocks came from nearby Lake Royer. The Chambersburg, Greencastle, & Waynesboro trolley stopped here for passengers to picnic. Seated at the Cascades is George Myers, who often purchased flowers picked by one of the Pen Mar area youngsters, Virginia Bruneske. (Courtesy Virginia Bruneske.)

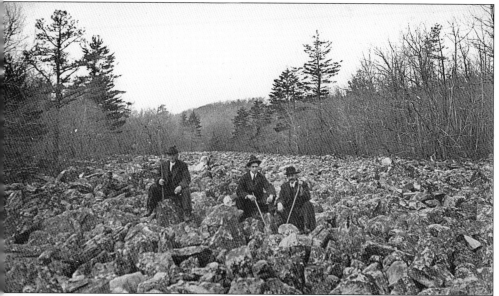

A short walk from Pen Mar was the Devil's Race Course, "a natural phenomenon that appears like a broad roadway of great stones, which extends away up the mountain in a path no human hand could ever build." The stones, which weighed as much as several tons, were thought to be a riverbed thousands of years earlier. The Devil's Race Course no longer exists, as many of the rocks were used to construct the Sunshine Trail from Waynesboro to Blue Ridge Summit. (Courtesy David Cline.)

Floyd Shover and a group of workmen stand by a gas mower at the Monterey Country Club near Blue Ridge Summit. The Monterey golf course was a favorite for Presidents Woodrow Wilson, Grover Cleveland, and Dwight D. Eisenhower. Former Blue Ridge Summit businessman Gene Cline remembers President Eisenhower playing at the course. Cline added that the President and Secret Service agents all wore similar hats in an attempt to conceal the identity of the President. (Courtesy David Cline.)

An early-1900s account of the Monterey Country Club noted "many people attended the semi weekly bridge parties, while a large group was present at the weekly tea. Large crowds throng the golf course, the ladies in hope of winning the tournament held for them this week and the men hoping to defeat the Sudbrook aggregation in their semi-yearly match." Mrs. Weldon Eshelman recalls that a visit to the club for tea called for ladies to "wear gloves and hats." (Courtesy Judy Schlotterbeck.)

The Blue Ridge Flying Service (above), operated by Arthur Pottorff, was located at Rouzerville. As a teenager, Virginia Bruneske paid $1 for "a joy ride" with her friend Patricia Trite in one of Pottorff's small planes. Below is Mentzer's Duck Farm, located near Waynesboro. Joe Baird remembers it as a "big duck farm. It produced thousands of ducks—found [on the menu] in summer hotels at Blue Ridge Summit." (Courtesy Virginia Bruneske.)

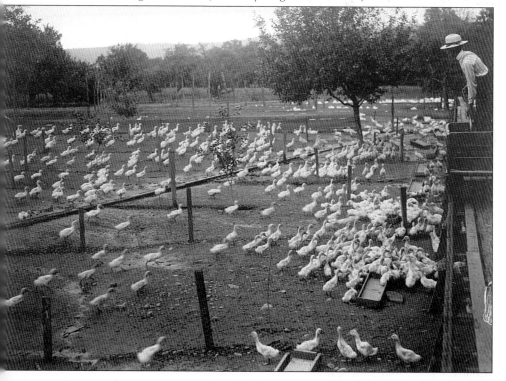

The Pen Mar Post Office closed on August 11, 1967, ending a long tradition that extended to the time when mail was brought to the post office by horseback to be placed on Western Maryland trains. For years the Werdebaugh family delivered the mail to local residents. (Courtesy Virginia Bruneske.)

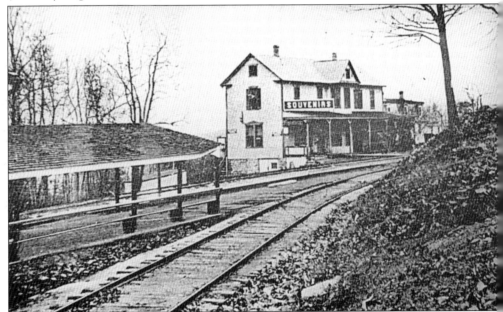

For 31 years, Helen Whitmore served as postmaster of the Pen Mar Post Office, which sat along the Western Maryland tracks just north of the Mason-Dixon Line. As a young boy, Lind Bumbaugh took the mail in a canvas bag to the post office, where he placed it on the mai crane. "If you had other bags to put on, you still hung that up, and if the train wasn't going t stop, you had to slow him by waving at him." (Courtesy Judy Schlotterbeck.)

Five

PLAYIN' IT AGAIN

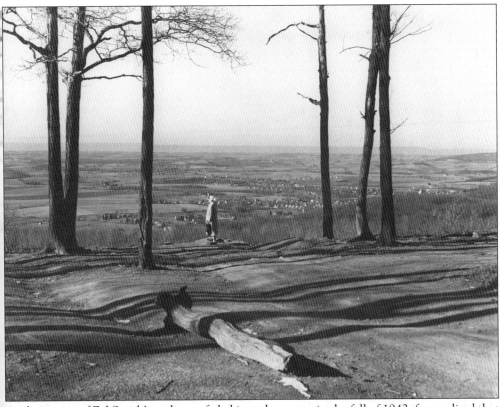

As the strains of Zel Smith's orchestra faded into the sunset in the fall of 1942, few realized that this would mark the end of an era at Pen Mar Park. In early March 1943, the WM began dismantling the park's amusements. Robert A. Fahnestock Sr., a WM section foreman, was one of those assigned to the task. As a youngster, Randolph Debrick watched the park disappear before his eyes. "They were tearing everything down, and they were burning it up!" This 1955 photo depicts the solitude of the once-vibrant park. (Courtesy *Maryland Cracker Barrel*.)

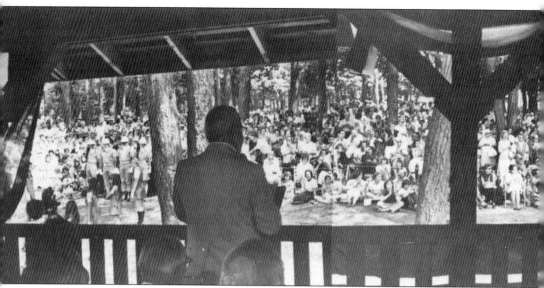

With the disappearance of the park, a group whose love for the site wouldn't die met in the late 1940s in an effort to revive the park. In 1976, visitors could once again stroll down the promenade and witness the park being reborn. On May 22, 1977, Washington County officially

The reopening of Pen Mar Park was a culmination of the efforts of Washington County and Maryland officials, along with individuals such as Robert R. Fleigh, president of the Bob Fleigh Foundation. Joseph E. Widmyer, director of the Washington County Board of Parks and Recreation, gave the opening remarks, while Martin L. Snook, president of the Washington County Commissioners, cut the ribbon. Ed Klitch from Radio Station WJEJ served as the master of ceremonies. (Courtesy Mrs. Zel Smith.)

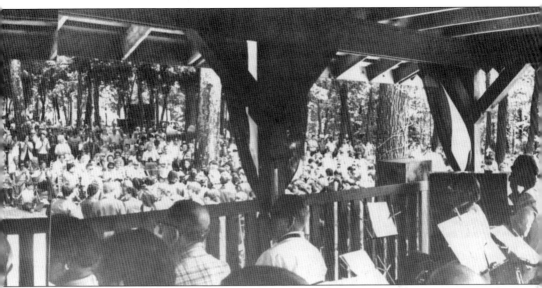

dedicated its new Pen Mar County Park. The new overlook served as the stage for the dedicatory program as thousands filled the park. (Courtesy *Maryland Cracker Barrel.*)

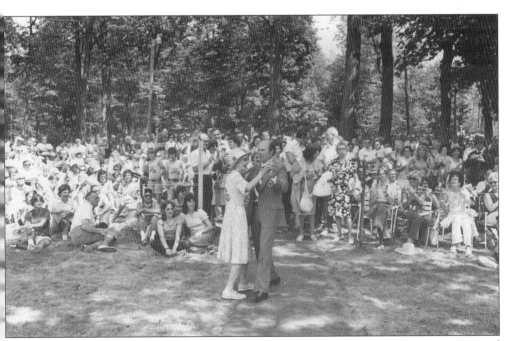

W. Keller Nigh III, vice president of the Washington County Commissioners, is pictured dancing to music played by Zel Smith and some of the former members of his Penn Aces. Other musicians joined Smith's band to serenade the crowd estimated at 3,500. The arrangements were by Fred Kepner, retired director of the Air Force Dance Band. (Courtesy *Maryland Cracker Barrel.*)

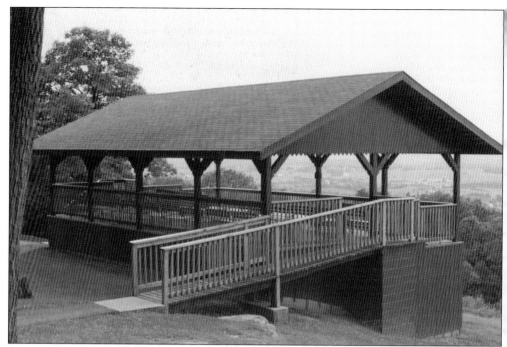

One of the first reminders of the past to reappear in 1976 was the scenic overlook above, designed to precisely imitate the overlook that disappeared in 1943. Plans were based on early photographs and postcards. Also included in the initial construction project were the interpretative center below, a picnic pavilion, restrooms, playground, and parking facilities. Gone are the railroad siding and trolley tracks that once brought throngs to the Blue Ridge Mountains, but today the Appalachian Trail runs through the park along the approximate route followed by the promenade from the Pen Mar Station to the park. (Courtesy *Maryland Cracker Barrel*.)

Jim Powers (right) is one of a host of musicians who perform at Pen Mar Park each year from May into October. Powers is associated with the American Federation of Musicians Local 770 in Hagerstown, who along with the Washington County Commissioners and the Washington County Recreation Department sponsor the concerts. Below are Powers and his wife, Fay, who is affectionately known as "Mrs. Pen Mar." A plaque from the Washington County Commissioners in the park's interpretative center recognizes the efforts of the couple in helping to promote Pen Mar Park. (Courtesy Jim Powers.)

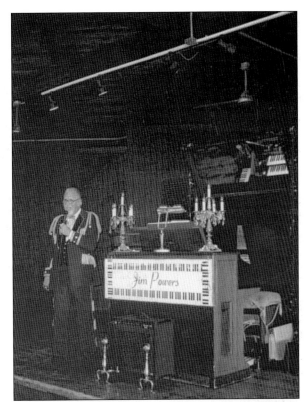

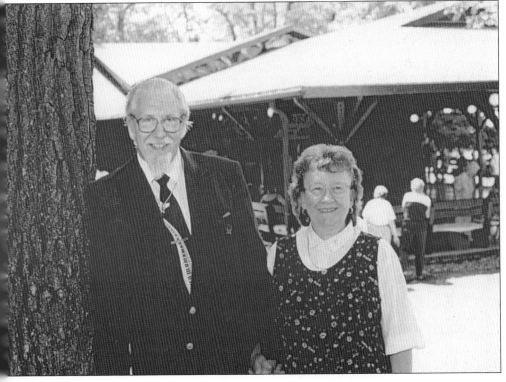

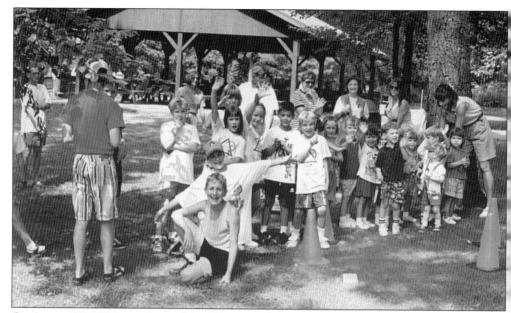

On August 27, 1994, members of the Trinity Lutheran Church in Hagerstown held a picnic at Pen Mar Park in conjunction with the church's 125th anniversary. Today, the park is still a popular site for picnics and reunions. In the 1920s, a Lutheran outing at Pen Mar attracted an estimated 15,000 people. The sixth annual Lutheran Reunion held at the park on August 21, 1891, featured the United States Marine Band. The following year the world-famous Moller Organ Factory in Hagerstown provided an organ for the Lutheran Reunion, which featured Prof. H.E. Manel, a celebrated cornetist, and a choir composed of members of various Baltimore churches. (Courtesy Hubert A. Brandenburg and Janet Dayhoff.)

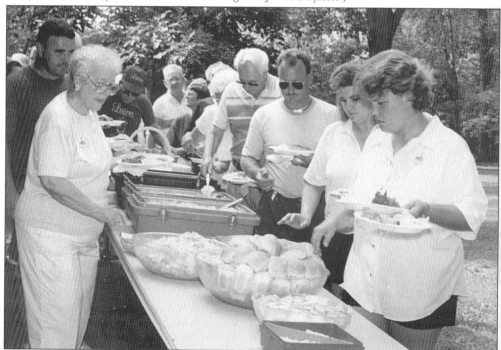

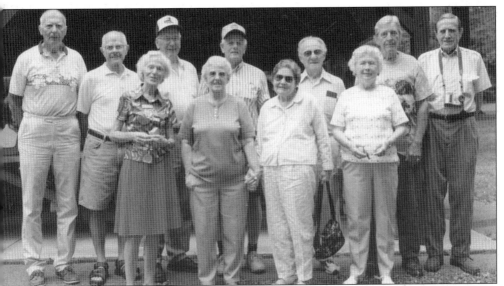

In 1978, Virginia Bruneske initiated a reunion of former Pen Mar Park employees. On Saturday, July 10, 2004, the tradition continued as the group held its 27th reunion at the park. Pictured are, from left to right, (front row) Dolores Getty Sattler, June Miller Cline, Betty Frazer Brown, and Virginia Laspe Bruneske; (back row) Jim Keenan, Charles Trite, Lindy Bumbaugh, Allen Smetzer, Frank Rosenberger, Randolph Debrick, and Paul Frazer. (Courtesy *Maryland Cracker Barrel*.)

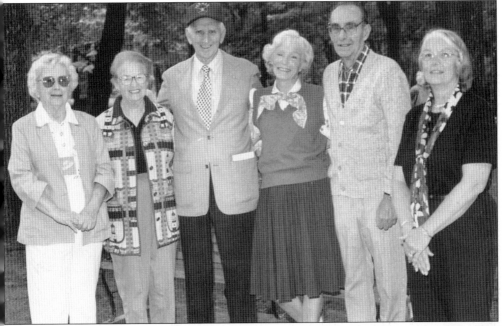

A stroll along the promenade still finds many who remember how the sights and sounds of the park created memories for a lifetime. They still come to the mountain sanctuary to renew acquaintances and relive those bygone days. Pictured above from left to right are Virginia Bruneske, Beckie Blair and her husband Earl, Dolores Sattler and her husband Gus, and *Maryland Cracker Barrel* associate editor Suanne Woodring. (Courtesy *Maryland Cracker Barrel*.)

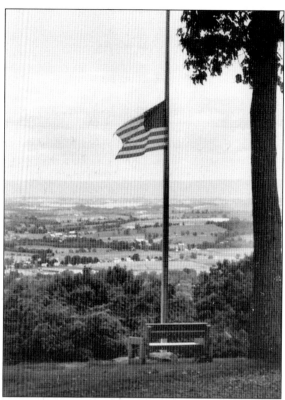

A solitary flag flies at half-mast over the Cumberland Valley shortly after September 11, 2001. Mrs. Zel Smith reflected, "It was a wonderful place to be, and in the summertime, it was so cool. You looked out over the valley. It was just a great place to be!" For Frances Cruger, "My very first love—I was five years old—was Pen Mar Park. What a thrill to board the Western Maryland steam locomotive [in Hagerstown]. Each stop—North Potomac Street, Chewsville, Smithsburg, and Blue Ridge Summit—were steps toward heaven." (Courtesy *Maryland Cracker Barrel*.)

"After all of the gaiety of the summer, I had an empty, lost feeling at the season's end. Ahead lay the cold, hard winter in the mountains and the ghostly quiet of that big empty hotel [Blue Mountain House]," reflected John J. Gibbons Sr. For many those days are indeed gone, but the memories still linger. (Courtesy Mrs. Zel Smith.)